THE STONEHOUSE VALLEY
VALLEY
THROUGH TIME
Howard Beard

AMBERLEY PUBLISHING

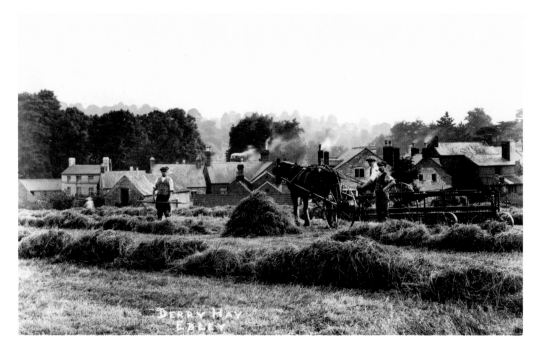

Haymaking at Derry Hay, Ebley, *c.* 1911.

This book is dedicated to my wife Sylvia; without her assistance and skills
its production would not have been possible.

First published 2012

Amberley Publishing
The Hill, Stroud
Gloucestershire, GL5 4EP

www.amberley-books.com

Copyright © Howard Beard, 2012

The right of Howard Beard to be identified as the
Author of this work has been asserted in accordance
with the Copyrights, Designs and Patents Act 1988.

ISBN 978 1 84868 048 7

British Library Cataloguing in Publication Data.
A catalogue record for this book is available from
the British Library.

Typeset in 9.5pt on 12pt Celeste.
Typesetting by Amberley Publishing.
Printed in the UK.

Introduction

When first approached to research a book on the Stonehouse Valley for the 'Through Time' series, all the villages from Stroud right up to the M5 motorway were considered. However, it very soon became obvious that far too much good, early material existed for a single volume. It was therefore decided to limit coverage to Cainscross, Ebley, the Stanleys and Stonehouse.

It was also necessary to ensure that, as far as possible, the old photographs were different from those published previously. Lionel Padin and Stanley Gardiner's book of 1989 included much of the same route, as did the present author's of 1996. Other writers, including J. H. A. Anderson and C. N. Harrison, have also produced illustrated studies of the area, so it was important to provide as many images as possible not already in print. In fact, only a handful of pictures presented here have been used before, and those few that have are included for good reasons.

Undertaking to compile a book such as this is both pleasurable and challenging. Research was begun in the autumn of 2011, with a publisher's deadline a year later. Clearly the present-day photographs would need flowers and trees in leaf to show off landscapes to their best effect. Sunny weather would also be desirable. Owing to extensive rainfall during spring and early summer, photography was in practice limited to a window of opportunity during a week of glorious sunshine in late May 2012.

Difficulties would also arise in choosing the right time of day for buildings to be in full sunlight – occasionally early in the morning. The author is grateful to several surprised passers-by who agreed to be included in shots, so as to bring foregrounds to life.

Another problem frequently encountered in the 'Through Time' series is the trees and buildings that prevent the present-day photographer from taking his picture on the exact spot where his Edwardian predecessor stood. Street furniture, wires, cables and yellow lines also tend to mar contemporary images. Their effect has been minimised wherever possible. Having said all this, the process of taking the modern-day photographs has been both rewarding and enjoyable. Much fascinating background information has also been acquired along the way, for which the author is grateful, as indeed he is to all those who offered advice, contributed images, or proofread the finished text.

The route eventually chosen proved varied and interesting, including as it does roads, railways and the Stroudwater Canal. Cainscross has existed as a parish only since 1837, created mainly from portions of the ancient parishes of Stroud, Randwick and Stonehouse. Ebley,

never an ecclesiastical unit in its own right but a settlement within the parish of Stonehouse, has particularly strong connections with the woollen cloth trade and nonconformism. It is now in the civil parish of Cainscross. The Stanleys are both villages with evidence of Roman occupation. The manor of King's Stanley, recorded in the Domesday Survey as Stantone, was once, as the name suggests, in the hands of the Crown. The priory church at Leonard Stanley – or Monk's Stanley as it was known in the Middle Ages – was originally dedicated to St Leonard. This later changed to St Swithun. Unlike the Stanleys, Stonehouse, also recorded in the Domesday Book, has undergone considerable residential and industrial development away from its original centre near St Cyr's Church and has acquired the status of a town, complete with a mayor.

Finally, the author would like to thank the congregation of Ebley Chapel and the residents of St Matthew's Court at Cainscross for providing him with group foregrounds; also the owners of Priory Farm at Leonard Stanley for permitting a photograph to be taken of what must surely be their most unusual temporary resident – an elephant.

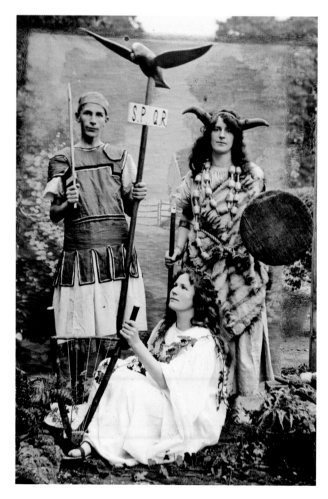

Participants from the Stonehouse area in the Mid-Gloucestershire Historical Pageant of Progress, 1911: a British Chieftainess, a Druidess and a Roman soldier.

Cainscross

Cainscross Road

During the first week of the summer holidays in 1945, Marling School headmaster J. M. Eagles decided to ask for volunteers to clear overgrown shrubs and trees screening the school from Cainscross Road. The headmaster himself, the caretaker and the physics master, George Pearce, all joined in and got their hands dirty. The 2012 photograph suggests that a similar project might perhaps be considered today.

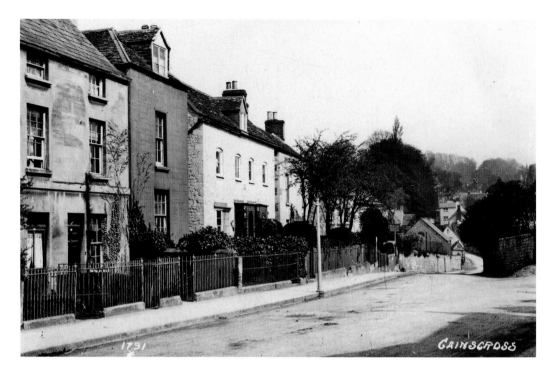

Paganhill Lane

In this picture taken around the time of the Coronation of King George V and Queen Mary in 1911, Paganhill Lane appears – to present-day eyes – strangely empty of traffic. That this is not a winter scene is proved by the absence of the top of the gas lamp. These were generally removed and stored for the lighter months of the year. Taking the new photograph involved standing briefly among the traffic, close to that notorious eyesore Tricorn House.

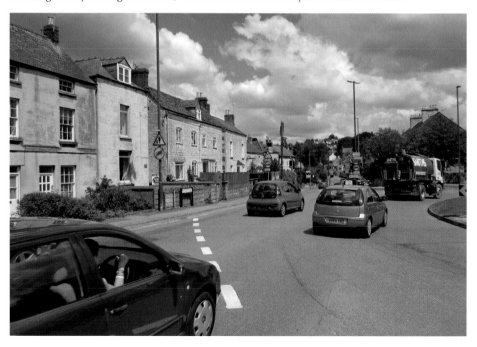

Business at Dudbridge

Sandlings ran a basketmaking concern at Dudbridge for many years. Previously they had been at Wallbridge and at Minchinhampton. Older residents will recall their premises, roughly opposite Redler's factory. The sepia photograph is believed to show the firm displaying a range of products at a Cainscross garden party sometime around 1915. The companion picture, taken half a century or so later, is of the Vale Stores – on the same side of the road – run by H. Richards.

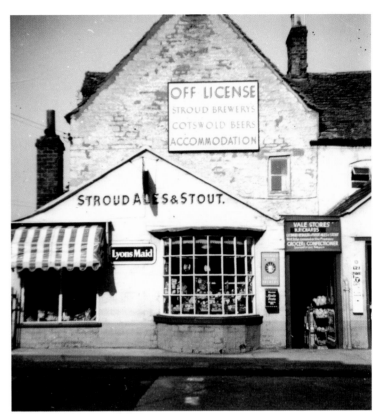

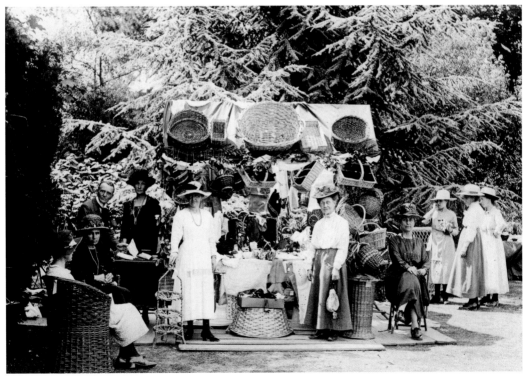

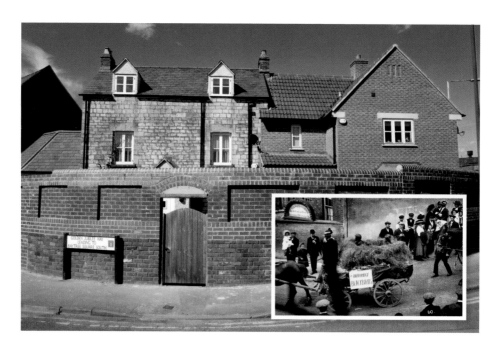

The Dudbridge Blackbird

In 1910 Samuel Hayden, of Vale House, Dudbridge, owned a tame female blackbird that he allowed to fly freely around his drawing room. The bird gathered scraps of material and other varied oddments, which it used to construct a nest on Mr Hayden's mantelpiece. Eggs, duly laid – but clearly infertile in the absence of a male bird – were exchanged by Mr Hayden for fertile ones he procured from the countryside. Once hatched, the Dudbridge Blackbirds became celebrated through local newspaper reports. At the ensuing summer carnival in Stroud, the young birds were represented by two boys covered in boot polish, in a large straw nest on a cart, as the inset shows. What a splendid piece of Edwardian social history! Vale House is the stone-built property in the modern photograph. The original nest is in the Museum in the Park.

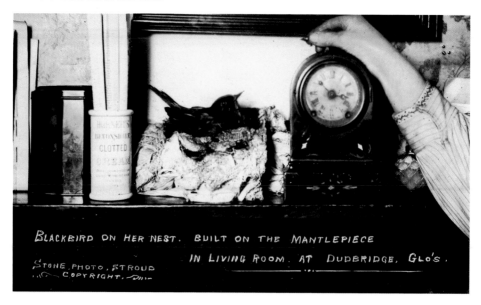

BLACKBIRD ON HER NEST. BUILT ON THE MANTELPIECE IN LIVING ROOM. AT DUDBRIDGE, GLO'S.

STONE. PHOTO. STROUD
COPYRIGHT.

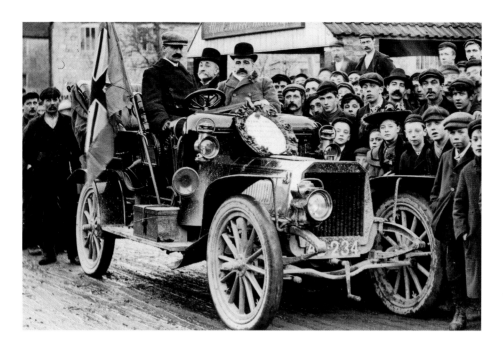

Electioneering

From 1900 to 1918 Stroud was represented in Parliament by Liberal MP Charles Allen, who lived at Paganhill in a mansion that once stood where Archway School is now situated – Farmhill Park. The arch itself marked the entrance to the estate. Mill owners were often Liberal supporters so, on a 1910 visit to factories at Dudbridge, Charlie Allen – as he was affectionately known to his supporters – was on friendly territory. In this 1910 photograph Mr Allen is wearing a bowler hat. The driver is Charles Apperly and Charles' father, Sir Alfred, sits between them. Apperlys Mill was later associated with the firm of Redlers and is now partly converted to private dwellings – 'Redlers Waterside'.

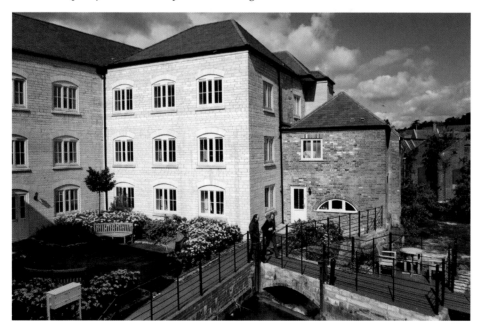

The Approach to Cashes Green

The old Cashes Green Hospital is visible on the left of the earlier picture, a postcard sent from Stroud to an address in Whitminster just before Christmas in the first year of the First World War. The left side of the present-day photograph shows modern houses on the approach to Hunter's Way, where the roads have names referring to the sport: The Beagles, The Bridle, The Bassetts, etc.

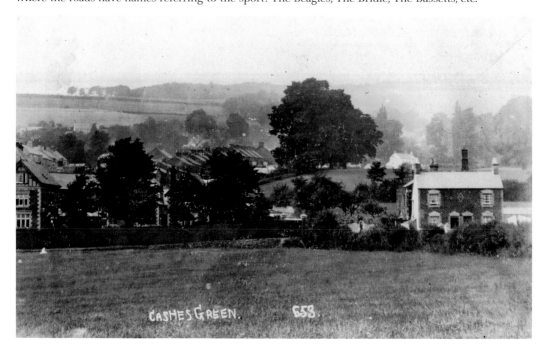

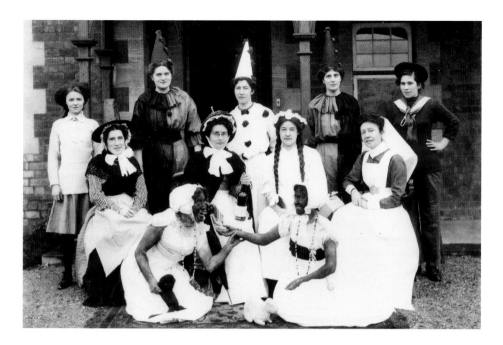

Cashes Green Hospital

For much of the last century the local area had three hospitals: the General Hospital in Trinity Road at Stroud, Standish Hospital west of Stonehouse and Cashes Green Hospital, which was built originally as an isolation unit. However, for many years up to its closure Cashes Green was primarily a geriatric hospital. As this book goes to press, many of Cashes Green's wards and secondary structures have already been demolished as part of a housing development. Happily, the well-proportioned main building is being retained and restored. The Edwardian photograph shows staff in costume, possibly involved in offering Christmas entertainment to patients.

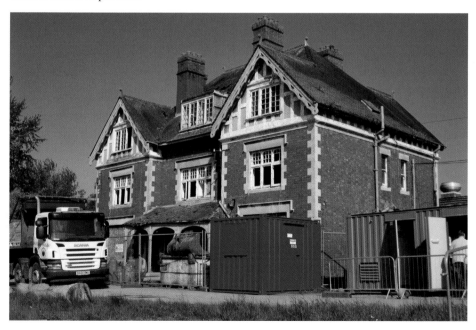

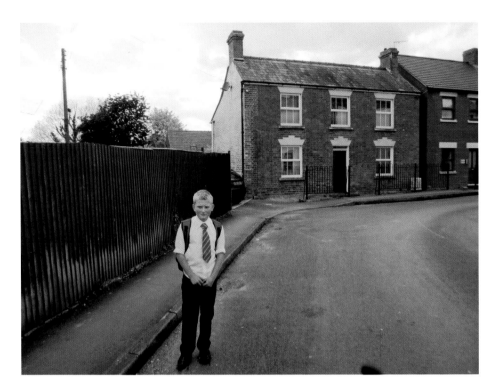

Cashes Green Post Office

Few present-day visitors to Cashes Green would suspect that Yew Tree Villa, at the bottom of Springfield Road, once had a lean-to building attached to it that housed a post office. The enamel plaques fixed to it include advertisements for Sunlight and Hudson's Soap, Lipton's Tea and Royal Daylight American Lamp Oil. To give life to the modern photograph, a passing schoolboy obligingly paused by the kerb.

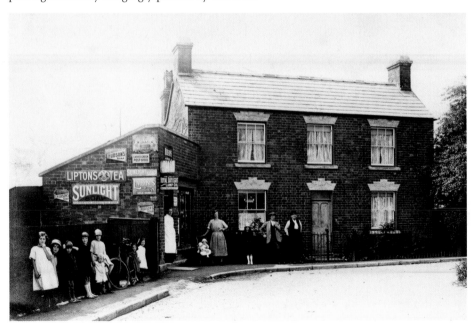

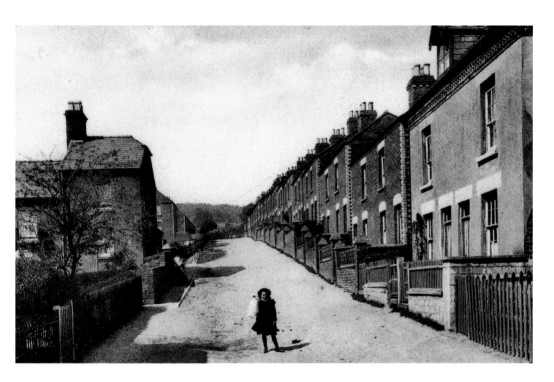

Springfield Road, Cashes Green

The sepia picture is in many ways remarkably similar to its counterpart taken a century later. The author enhanced the similarity by being permitted to position young Tom Williams where the Edwardian child had stood. However, lamp posts, wires and parked cars – plus the addition of a porch on the nearest house – remind us of the passage of time.

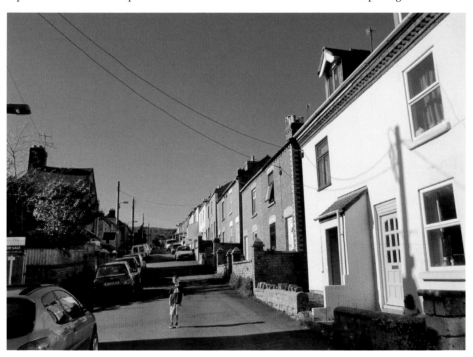

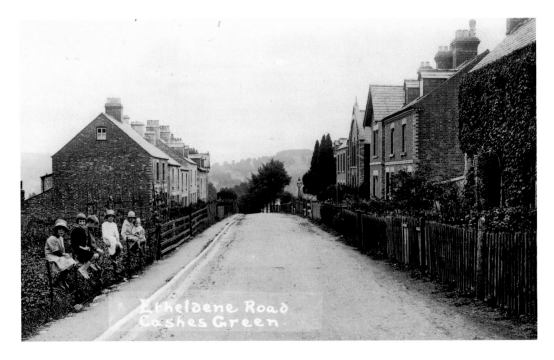

Etheldene Road, Cashes Green

The earlier photograph is a postcard from the studio of Rodborough photographer William Adams (1884–1967). It was taken around 1930, a date reflected in the cloche hats worn by the girls perched on the railings. The Methodist chapel among the row of houses on the right was familiar to the author many years ago as the venue for Easter cantatas, rehearsed and conducted by the late Mr Charles Ferris, whose widow is still alive at the remarkable age of 104.

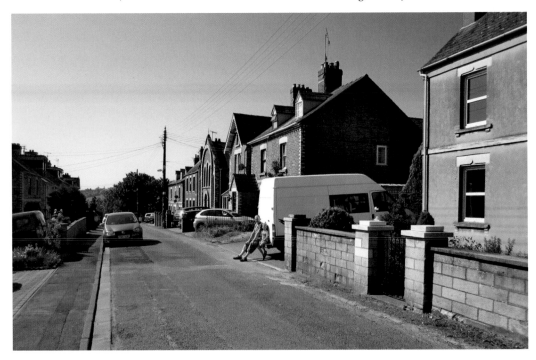

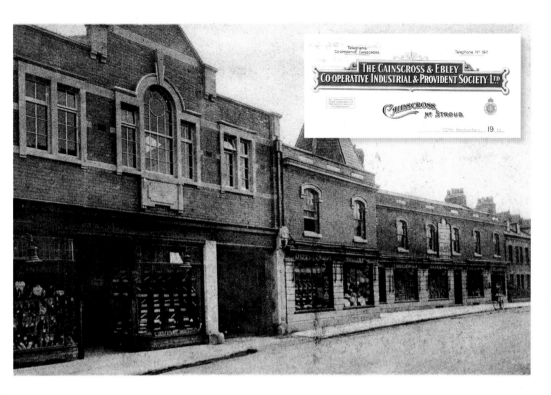

The Co-op Headquarters

The Cainscross & Ebley Co-operative Society was established in 1863. Its Golden Jubilee in 1913 saw the opening of the society's hall, on the left of the picture, and extensive celebrations throughout the area. Mottoes that underline the movement's beliefs survive in gilded letters at the top of the building to the right of the hall. The society no longer exists and the building is now occupied by the parish council and private businesses.

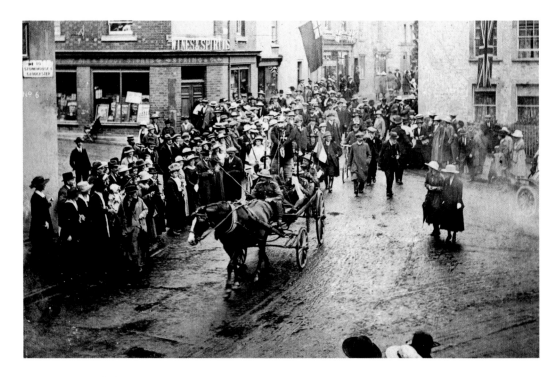

The Hospital Carnival

Cainscross Carnival, which supported Cashes Green Hospital, once played an important part in the local social calendar. A number of photographs exist from years around 1923, but the caption on the back of the chosen picture suggests a date slightly earlier. 'Karparts', on the corner beyond the road to Cashes Green, was Spring's grocery store a century ago. The buildings on the right were lost to road-widening. The nearer shadow in the modern photograph is cast by the castellated toll-house at the top of Bridge Street. Tricorn House, in the distance, casts a shadow both literally and metaphorically.

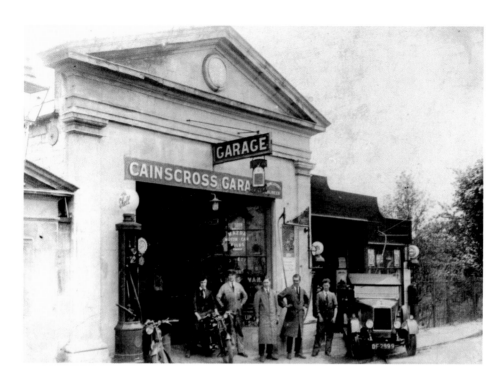

From Silver Screen to Windscreen

Films were screened around 1914 inside the fine, pedimented edifice in the earlier image when it was the Picture Theatre, run by manager Carlton Revell. By 1924, when this photograph is believed to have been taken, the building had become Meadows's Garage. Today the site is empty and all that survives is the smaller matching pediment over the gateway through to The Retreat. The garage picture, along with others, was lent to the author by the late Mrs Horton, with whose family the site was connected.

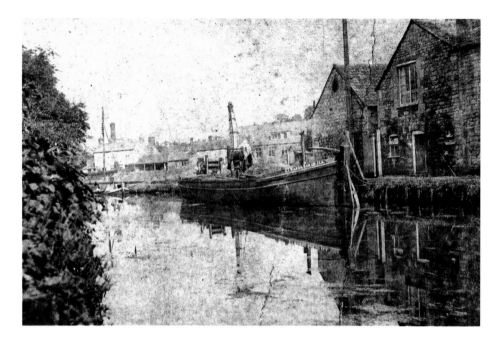

Boats on the Canal

Much enhanced from a very faded original, the postcard image above shows a barge tied up at Dudbridge Wharf. It was owned by E. T. Ward, Stroud coal proprietor. Beyond it is the celebrated 1850 crane – preserved and fully described in an industrial archaeology article by Dr Ray Wilson. The modern photograph, taken further along the canal near Ryeford, is of the boat owned by Colin and Nicky Rudall – seen taking part in the successful Stroud on Water Festival staged during Diamond Jubilee week in 2012. The steam launch is named SL *Margaret Morrison*, after the nanny of a former owner.

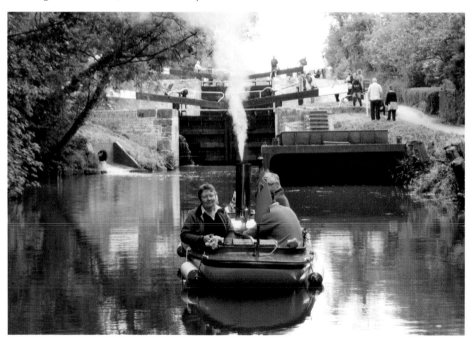

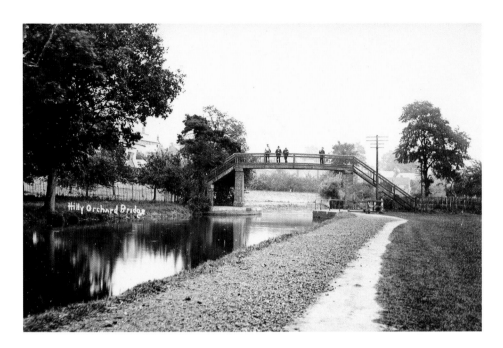

Hilly Orchard, Cainscross

The period image is taken from a 1906 postcard by E. P. Conway, the Nailsworth photographer, written by him to a family member in Gloucester. The bridge was high in order to allow the passage of trows beneath it. The coloured picture shows the rebuilt footbridge and, interestingly, the low-level temporary one that was put in to allow pedestrians to cross the canal while its predecessor was being reconstructed, and which was removed with literally minutes to spare before the 2012 Stroud on Water Festival opened.

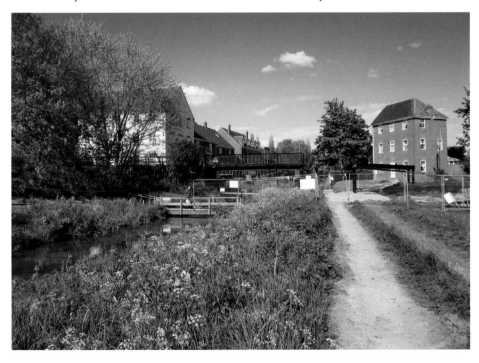

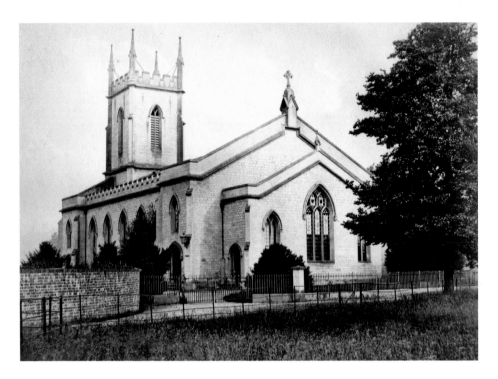

Cainscross Church

Cainscross ecclesiastical parish was formed in 1838 out of portions of Stonehouse, Randwick and Stroud parishes. The church, built a year earlier, is dedicated to St Matthew and was enlarged between 1897 and 1901. The extensions cost £5,638. The sepia picture is from a collection of local churches taken by Stroud photographer Oliver Smith around 1873. The modern picture shows how much the east end of the building has changed.

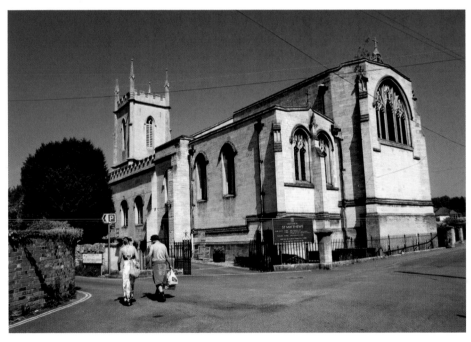

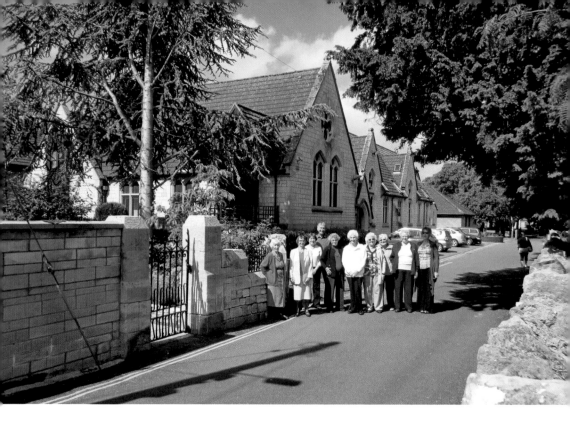

Cainscross School

St Matthews School was put up in 1877 at a cost of £3,000. In 1910 – roughly when this picture was taken – the school roll numbered ninety-eight boys, ninety-four girls and sixty-nine infants. For many years the building – now no longer a school – has provided residential accommodation for the elderly, a group of whom kindly posed for the author in June 2012 on the same spot where the children had stood a century before.

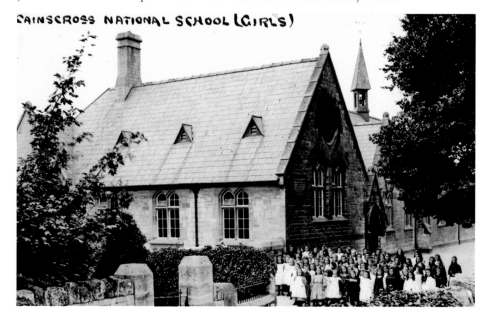

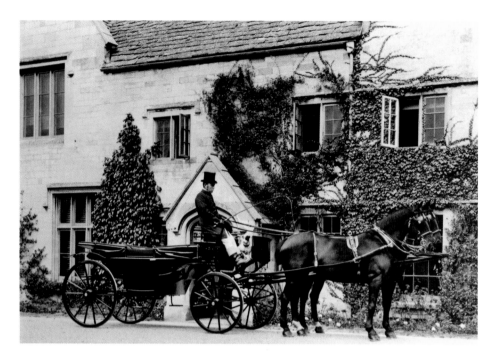

Elmfield House

In 1910 the Misses Spry Davies lived in Elmfield House. The carriage drawn up at the door is driven by Henry W. Fry, whose descendant, Mr L. Baker of Selsley, gave the author a copy of the picture. Externally largely unaltered, today the house has been subdivided and a hedge planted to the right of the porch.

Ebley

Main Road, Ebley, Looking East

The Cheltenham photographer who took this fascinating picture in 1910 clearly understood the value of incorporating large numbers of children into an image. (Their parents would all buy copies of the resulting postcard.) Interestingly, the card was written in French and sent by a lady called Marie to a friend in Nice. Marie clearly ran out of space on the reverse and continued her message on the front. Because it was sent abroad, the postcard required a red penny stamp rather than the green halfpenny one needed for inland mail.

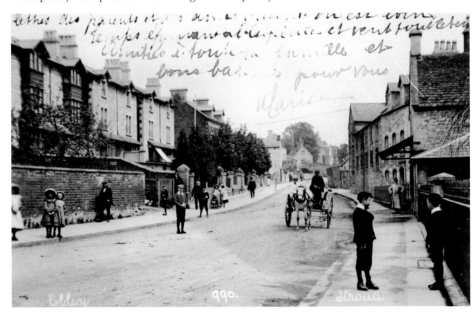

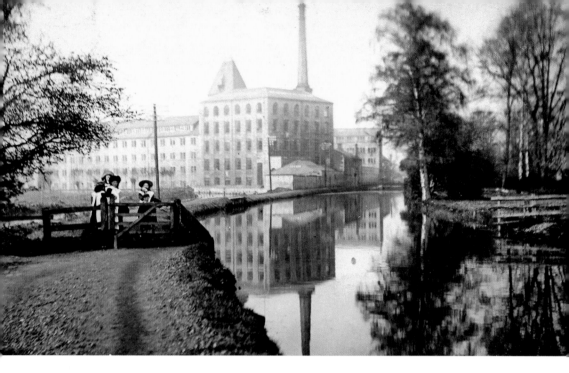

Ebley Mill

This Edwardian view, with its clear reflections, was taken by E. P. Conway of Nailsworth in 1907, when the mill, owned by the Marling family of Stanley Park, Selsley, was still in full operation. Today it is, of course, the headquarters of Stroud District Council. The canal is currently under restoration and it is pleasing to see boats using it once again. The inset picture shows how Stroud people learned to swim before the Stratford Park pool was opened in the 1930s. Note the diver in full flight!

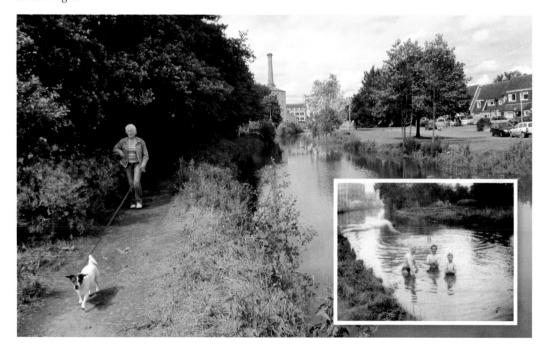

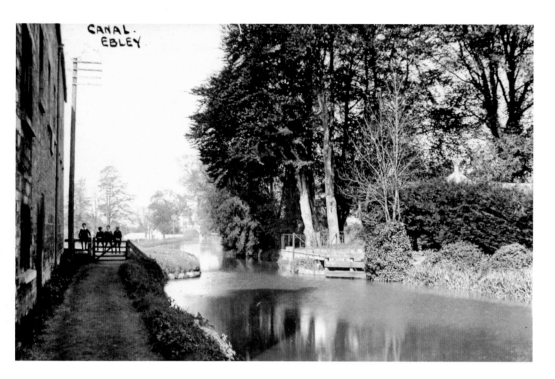

The Stroudwater Canal Near Ebley Mill

What was once an unimportant swing bridge over the canal has recently been replaced by a fixed one providing the main access route to Ebley Mill. The buildings on the left of both photographs confirm that we have the correct location, although the modern picture is taken from a little further back in order to include the lock gates. So much has changed here at Ebley. Note the large, relatively new residential estate in the distance and the current building work taking place on the right.

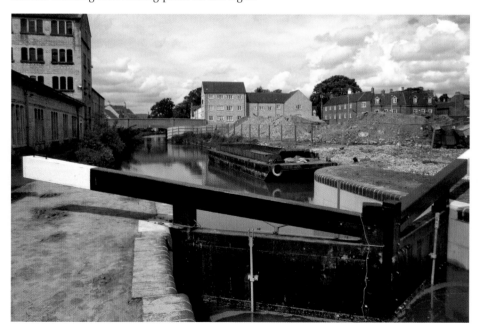

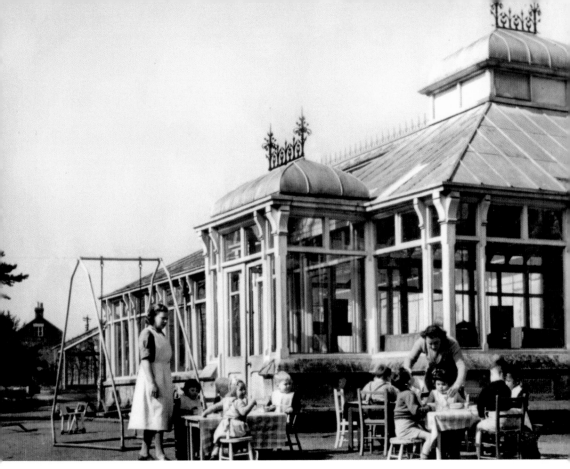

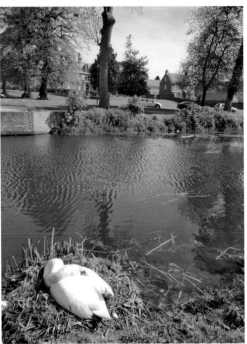

Ebley House

Most people will associate this building with the orphanage it housed for many years and the annual firework display that took place in its grounds. The sepia photograph from the early 1950s shows the author's late sister-in-law June Strange *née* Gazzard (*left*), during her training as a nursery nurse at the orphanage. In the modern picture, taken from across the canal, Ebley House is seen through the trees on the left. The nesting swan was chosen as an attractive foreground. Incidentally, a moorhen was also swimming nearby, keeping an eye on an over-adventurous chick.

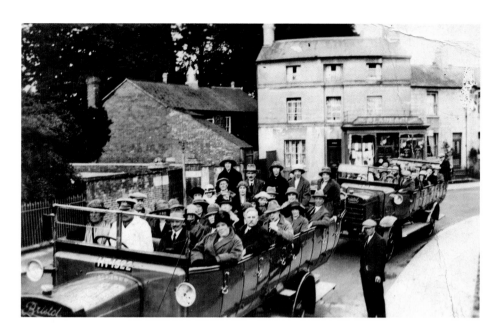

Slade's Grocery Store

This shop, with its distinctive curved frontage, was run as a grocery business for many years by William Slade. The earlier image, taken around 1923, shows a charabanc outing passing in front of the store. Seated in the vehicles are members of Ebley Recreation Club. The author recalls visiting the brick building to the left of the shop with his father, around 1953, in order to buy a pet rabbit.

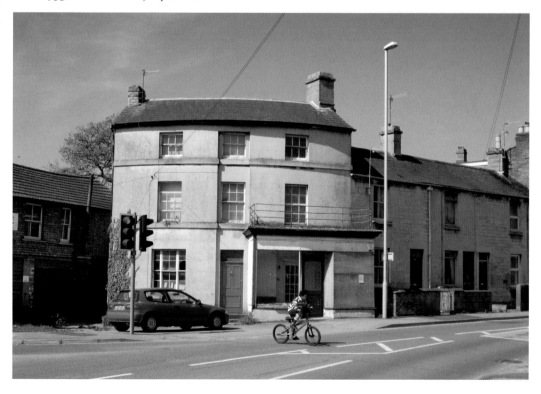

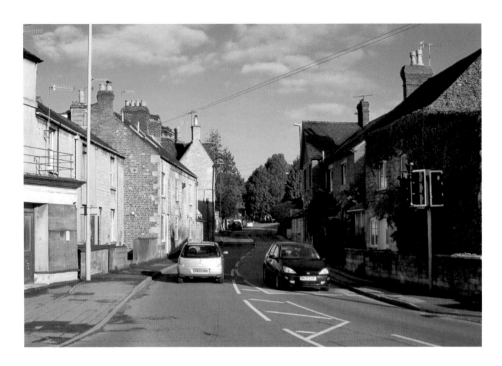

The Main Street, Looking West

What was later Slade's store was run by a family named Turner when Frederick Major of Bisley photographed Ebley in Edwardian times. He has attempted to bring his photograph to life by including children and horse transport. In more recent years local people will recall Gilbert Tindall's cycle shop, which operated from a single-storey building further up the road on the right-hand side.

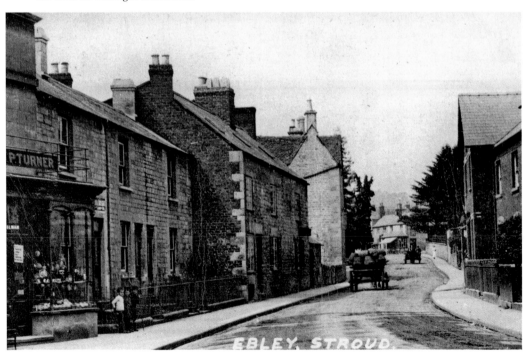

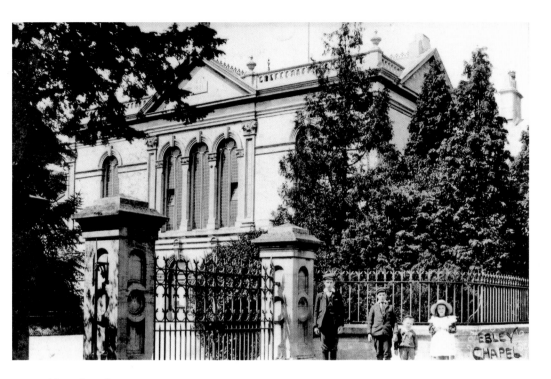

Ebley Chapel

Ebley Chapel was founded in 1797 and rebuilt in 1881. The main building has now gone – a sad loss architecturally. Modern houses have been put up where it once stood, though its stone entrance gate pillars survive, as the present-day photograph reveals. An Edwardian postcard exists that shows its then minister, Revd Robert Nott, and the chapel interior. Since there is no Anglican representation at Ebley, the chapel has always been important to the local community.

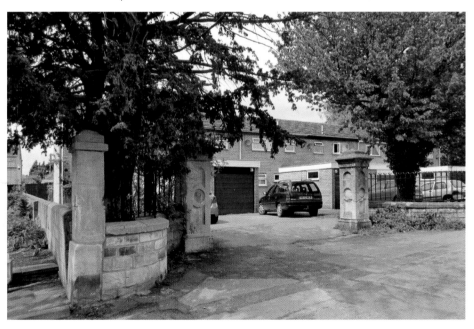

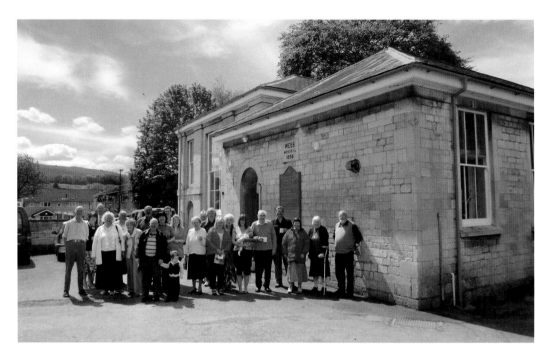

Ebley School

The old school at Ebley was built in 1840 and partially reconstructed in 1896. In 1910 it had 145 pupils on roll. The building has been taken over for use by the chapel, whose congregation the author encouraged to pose where the schoolchildren stood a century ago. Photographer Frederick Restall of Stonehouse appears to have said to the pupils, 'Boys, pretend to be playing football! Girls, just give them space!'

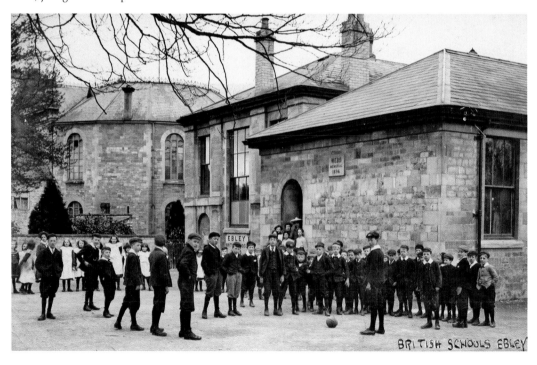

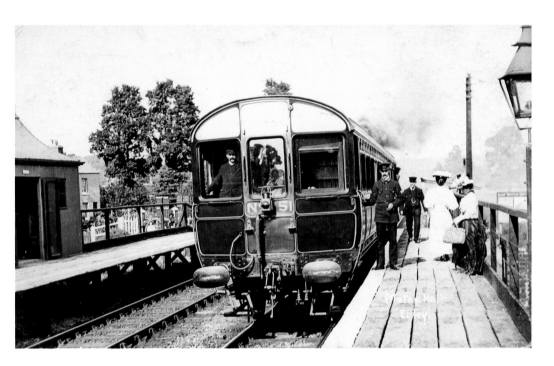

Ebley Halt

In 1903, the Great Western Railway introduced railcars to the Stroud district. Halts were built at regular intervals between Chalford and Stonehouse, provided – as here at Ebley – with 'pagoda-style' waiting rooms. The first railcars had motors within the carriage; it was later that coaches were pulled by tank engines. Today at Ebley only the crossing itself survives; Dr Beeching ensured the removal of the platforms and waiting room. In their early years the railcars were hugely popular and used extensively by local people.

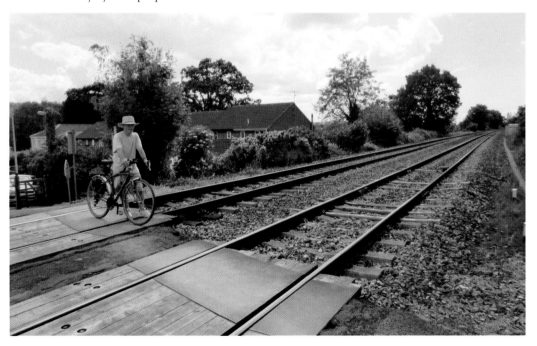

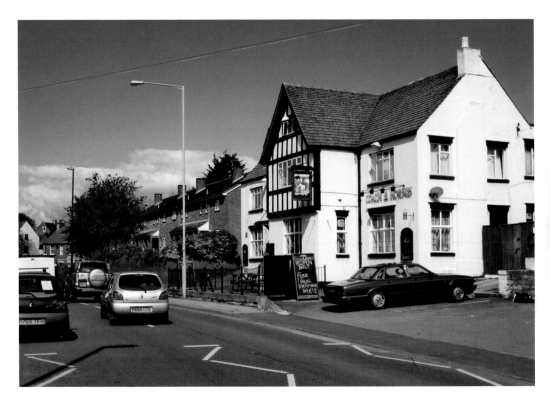

The Coach & Horses

When the earlier photograph was taken, probably in the 1920s, The Coach & Horses at Ebley was served by Stroud Brewery Company, as its sign proves. Over the years the building has been considerably altered. The terrace beyond it, with its central gable, has been replaced by modern housing. In the earlier image note the postman cycling by in the centre of the road – inadvisable today.

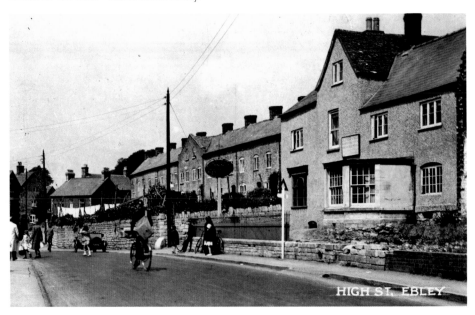

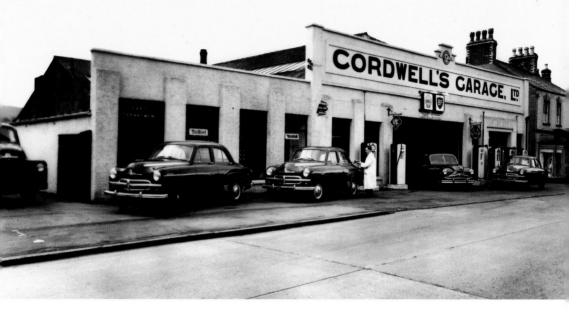

Cordwell's Garage

Cordwell is a well-known local name. One branch of the family lived at Woodchester, another ran a brewery at Cainscross. Cordwell's Garage at Ebley has for many years operated the area's Vauxhall dealership, as it still does today. The later picture, by Edwin Peckham, shows that petrol – both Shell and BP – was dispensed from its forecourt. The photograph was probably taken in the late 1950s, or early 1960s. However, going back to the period just after the First World War, the site was the business premises of woodturner George Maisey. Fixed to the end of his workshop is a notice advertising Victory Loans.

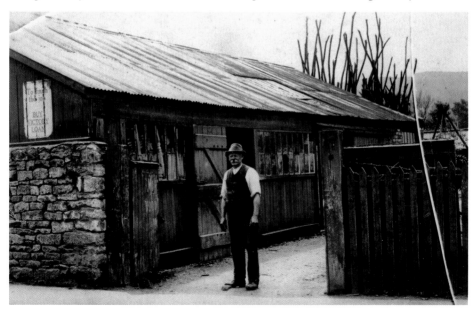

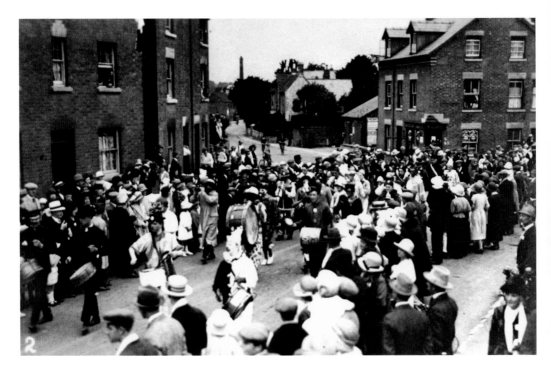

Foxmoor Lane Junction, Looking West

The postcard from which this photograph is taken does not reveal what occasion it depicts, but many of those in the procession are in fancy dress, so it is probably an event from the 1920s, possibly a hospital carnival. *Kelly's Directory* for 1927 records Arthur Scott as the proprietor of a grocery store in Ebley and it is his premises we see on the right of the picture. A poster to the left of his shop advertises a show at the Palace Cinema in Cheltenham.

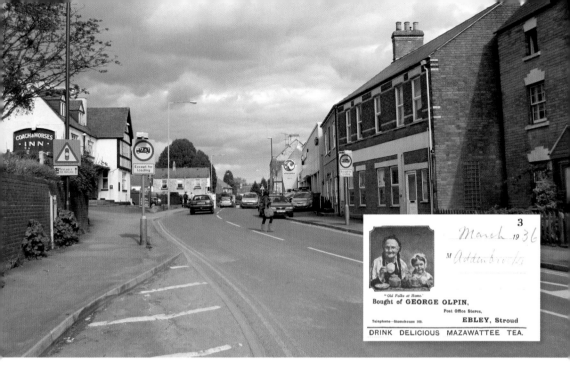

Foxmoor Lane Junction, Looking East

This interesting picture from around 1905 shows a horse bus and, behind it, a covered wagon carrying what appears to be hay. On the right is Ebley post office, where Mrs Sarah Olpin was sub-postmistress. Her husband George ran the shop and published postcards. On his wall are signs advertising, among other products, Mazawattee Tea, Lifebuoy Soap and both Fry's and Rowntree's Cocoa. The inset shows their business letterhead.

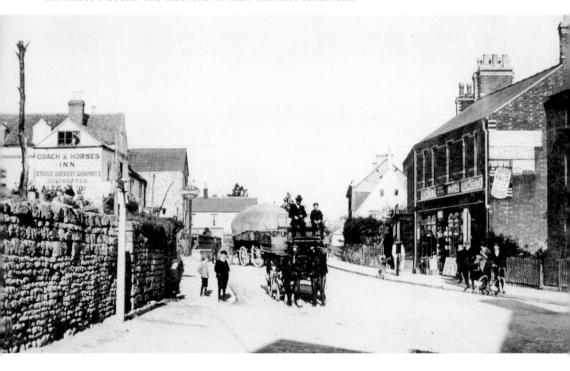

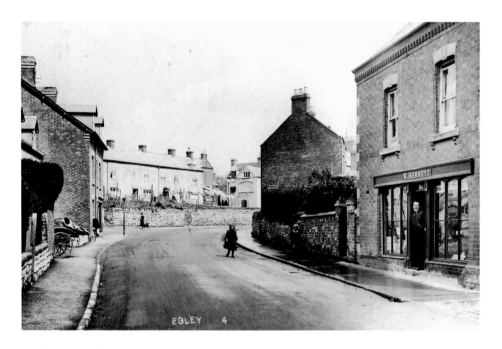

Walter Merrett's Shop

During the early 1920s Walter Merrett ran an umbrella repair business in this shop, which was divided in two. In the right-hand section Walter repaired and re-covered umbrellas and in the left part his wife Rosa sold postcards, produced mainly by Walter's younger brother Mark, who was a prolific photographer. Sadly, Walter's business was short-lived, owing to his poor health. He is pictured in his shop doorway. The modern photograph shows evidence of the building's former display windows.

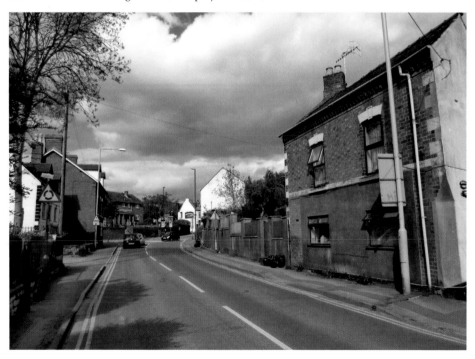

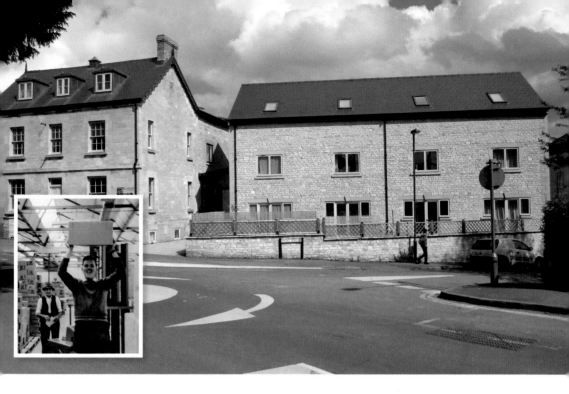

Ebley Laundry

The scale of the Stroud Sanitary Laundry Company's business may be assessed from the size of the building it occupied. When the author was familiar with the site, around 1963, it was used by the Cainscross & Ebley Co-operative Society as its warehouse. (The modern inset picture shows the author proving he could then lift heavy cases of tinned goods above his head! It was taken by the warehouse manager.) Now demolished, the building has been replaced by the block of houses on the right of the colour photograph – part of Dolphin Munday Court.

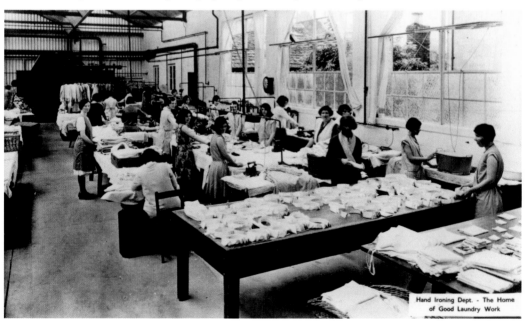

Hand Ironing Dept. - The Home of Good Laundry Work

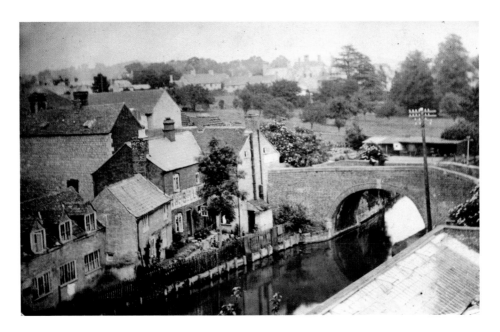

Oil Mills Bridge

The eighteenth-century arched canal bridge has now been replaced, as the modern picture shows. The 1906 picture is the work of Nailsworth photographer E. P. Conway and was taken from an upstairs window in the Georgian building still standing near the bridge, Holly Tree House. The Bell Inn, across the canal, long since stopped selling beer. It has gone, as have the nearby cottages. It is interesting to note in passing that, a century ago, thirty-six businesses existed in Ebley, including two cider merchants, a wire worker, a cooper and a watch- and clockmaker.

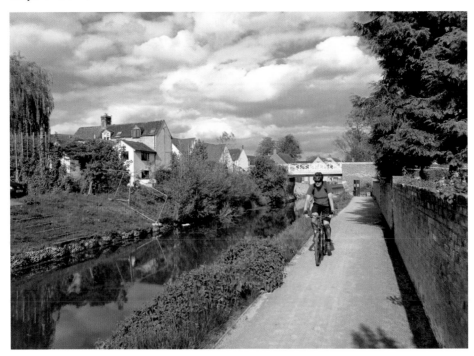

Foxmoor Lane

The same Cheltenham photographer who took the photograph of the main road at Ebley looking east was responsible for this delightful picture of Foxmoor Lane. It might perhaps be subtitled 'a study of Edwardian childhood'. Several of the children are known to have lived in Elm Terrace, seen on the left of the picture. They include William Miles Davis, his brother George and sister Mary. The home-made cart on the left was constructed from pram wheels and a lard box, as the writing on its side makes clear. Such a construction is reminiscent of the 'trolleys' the author and his contemporaries built for themselves in the 1950s.

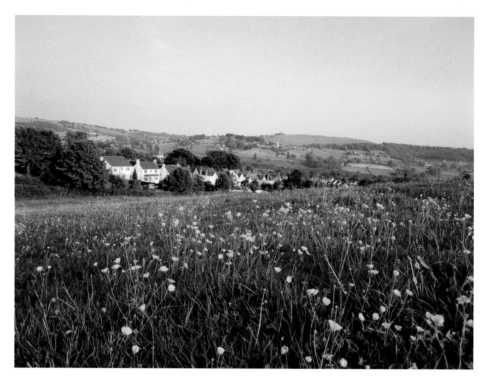

A View over Foxmoor Lane to Selsley

The person responsible for the period photograph looking down over Foxmoor Lane is not known, but it is a charming pastoral scene with the sheep in the foreground. Its modern counterpart shows the extent of later housebuilding along the lane. The author was fortunate to be visiting the field to take the contemporary picture when the buttercups were at their best.

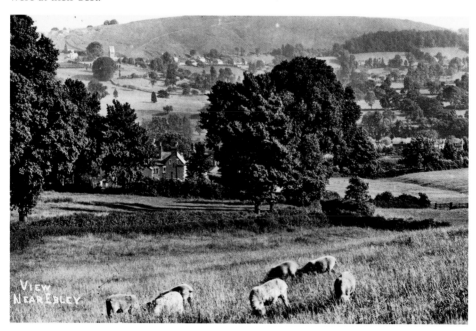

King's Stanley

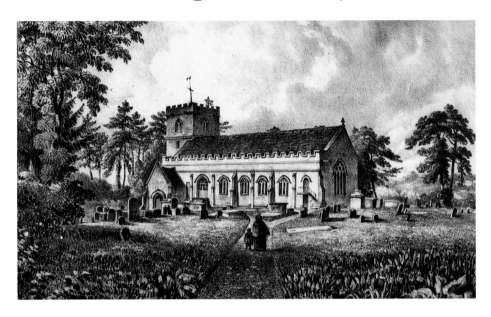

St George's Church Exterior

Probably set in a somewhat idealised landscape, this 1830s print of St George's Church nevertheless provides a record of the building between its 1820s extension and restoration in 1874. External gallery entrances can be seen at the east end and also via the window to the right of the porch. The later alterations included lengthening the chancel by 8 feet, as a comparison of the two pictures shows. The yew trees, now so distinctive a feature of the church path, were planted in 1878.

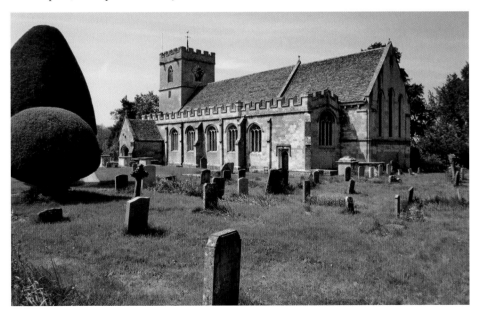

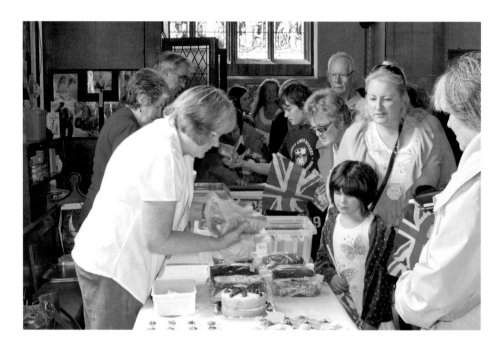

St George's Church Interior

The exact date of this early sepia photograph is not known, though it must be after 1874 since the three-light east window is in place. Equally, it must predate the installation of the chancel screen in 1891. The lamp brackets have now gone, as has the panel above the altar – which reads, 'He Gave Gifts To Men' – and the painting over the chancel arch. The modern picture was taken during Diamond Jubilee weekend 2012, when the pews were moved to the side. Cakes were sold by Sue Page (nearest to the camera) while Elizabeth and Peter Griffin ran a bookstall.

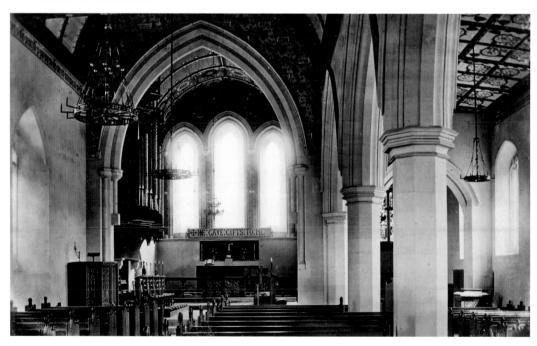

St George's Avenue

No part of King's Stanley has changed more than St George's Avenue. The sepia photograph dates from before 1915 and shows the approach to the church shaded on both sides by tall trees. Between the wars detached houses were built along the right-hand side, while opposite an estate was put up – so records say – by the author's grandfather, W. E. Beard, who ran a building business in London Road, Stroud.

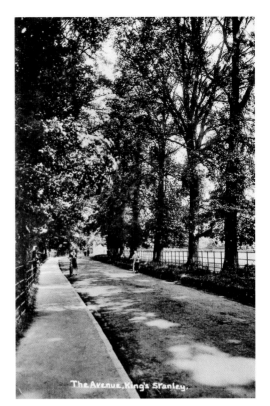

The Avenue, King's Stanley.

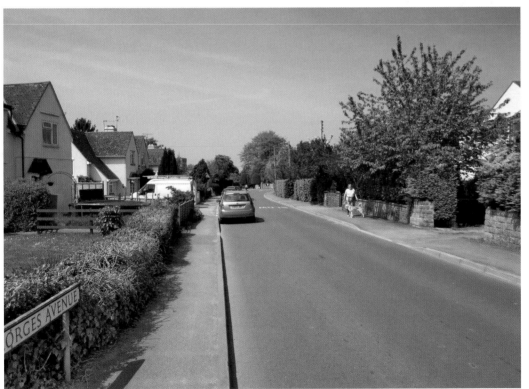

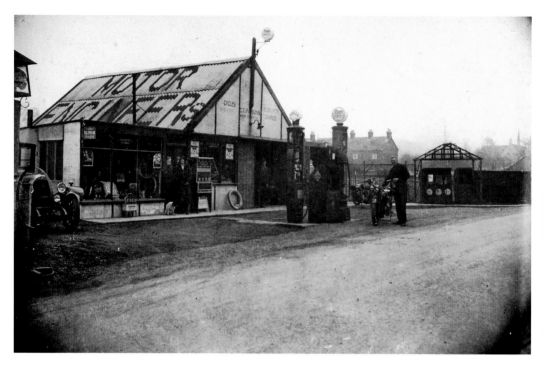

The Garage

King's Stanley Garage – now Kings Auto Centre – was established around 1930 by George Parkins, seen here standing with a motorbike in front of his petrol pumps. The globe above the left one says Shell and the right one Pratts Commercial. George died in 1989, a month short of his centenary, leaving in his will £10 worth of groceries to each of a hundred pensioners in the village.

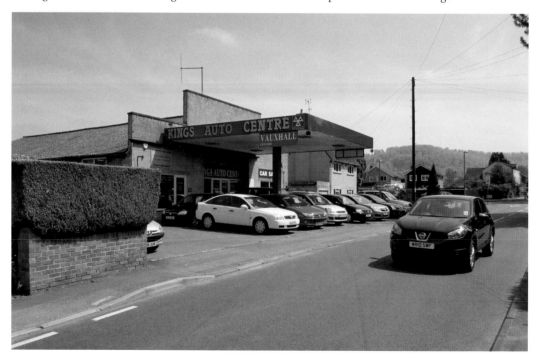

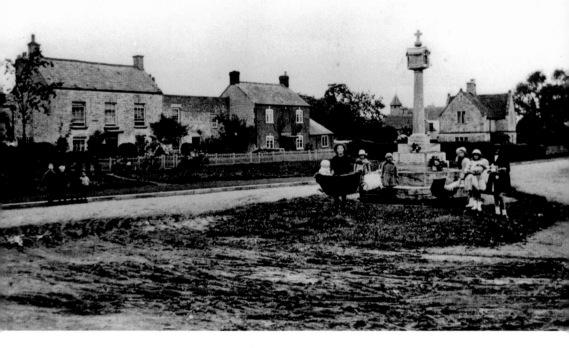

The Green

The black-and-white picture must date from the early 1920s, soon after the war memorial was erected, judging from the style of the children's clothes. Note the rough, muddy surface in the foreground. A copy of the photograph, together with one used further on in this book, was given to the author by the late Mrs Holley who, with her husband, ran a grocery shop nearby.

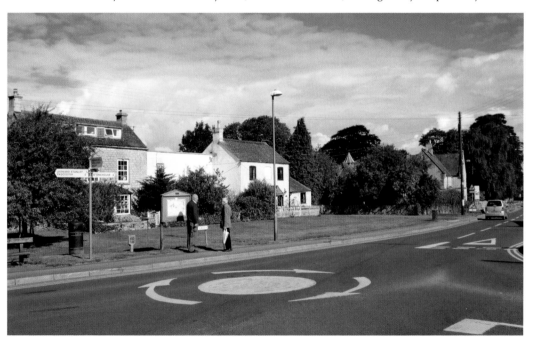

The Village Stocks and Whipping Post

Here on the Green stood the parish stocks. Those guilty of petty crimes would have been seated with their legs in the apertures. An upper section of the stocks – missing since at least 1868 – would then have been fastened down, leaving offenders to be ridiculed and pelted with fruit (and worse) by villagers. The *Victoria County History of Gloucestershire* suggests that the use of these stocks was briefly revived in the 1850s. The author persuaded a helpful passer-by to stand on the exact spot where the stocks once stood. The whipping post provided an alternative form of punishment.

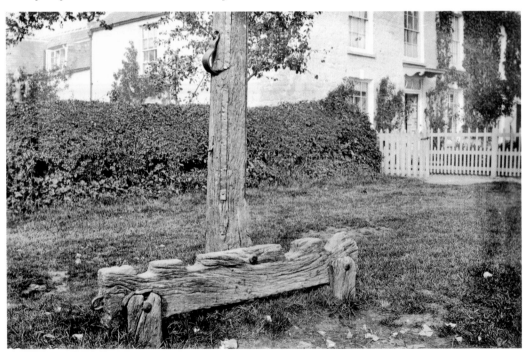

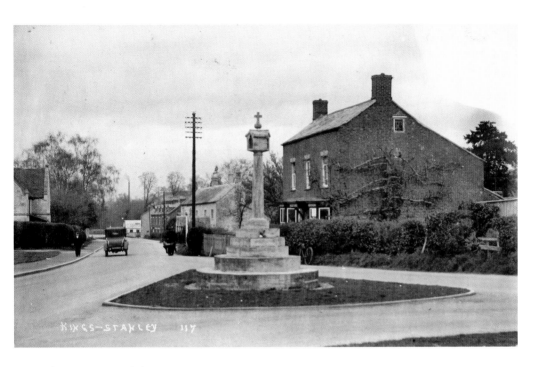

The War Memorial

A comparison of these two pictures shows that the war memorial has been re-sited so that it no longer stands on an island in the road. It was dedicated in October 1920 by Lady Marling from Stanley Park. Eighty-five villagers fought in the First World War, with twenty-four killed. These figures, reflected in similar numbers across the land, underline how scarcely a family remained unaffected by the conflict.

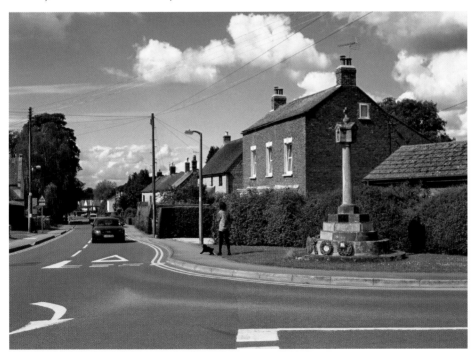

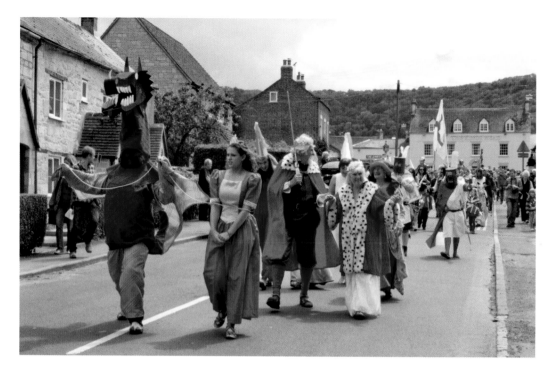

The King's Head

In 1910 King's Stanley had two public houses: the King's Head, shown here in a 1920s image, and the Red Lion across the Green. In addition there were six buildings occupied by what the *County Directory* describes as 'beer retailers'. Today the King's Head alone survives, having recently been closed then re-opened. It was first recorded in 1766. The modern picture has the pub in the background, with the splendid Diamond Jubilee Pageant procession in the foreground.

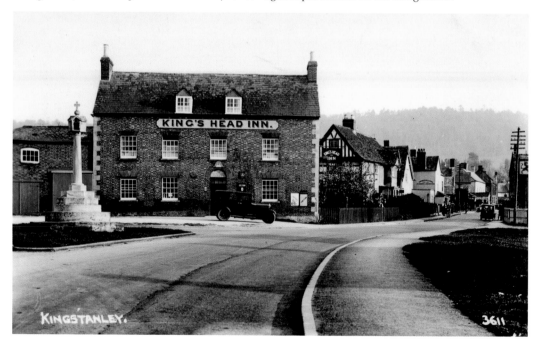

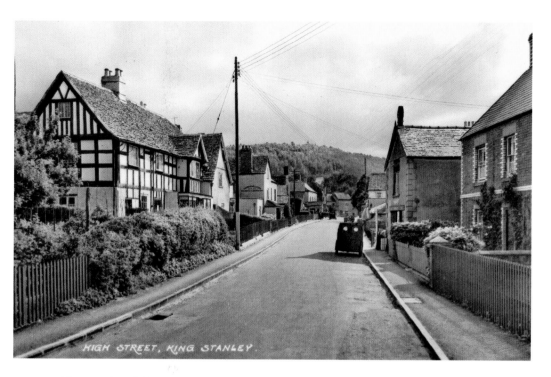

Looking up the High Street

What appears to be the same telegraph pole appears in both photographs. The half-timbered building behind it is unusual in a village where stone and later brick are the norm. Once again the author has trespassed on the goodwill of local people to enliven the foreground of his picture. Bassett's shop, outside which the van is parked, had been demolished since the earlier photograph was taken.

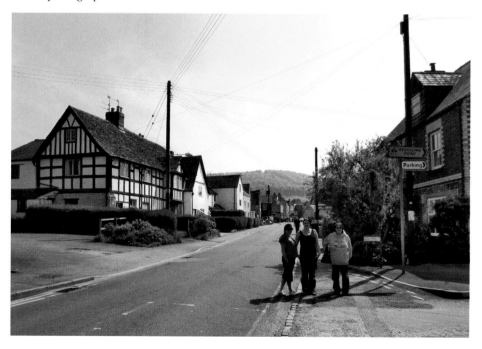

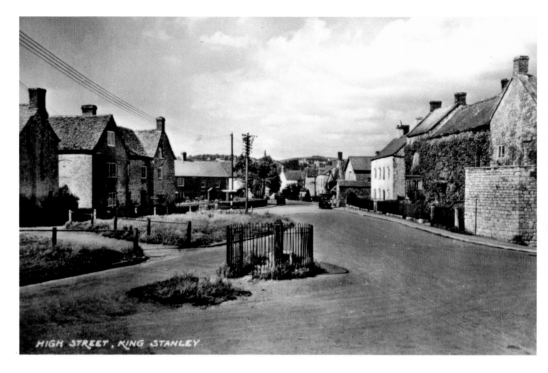

HIGH STREET, KING STANLEY

Looking down the High Street

Once again wires and telegraph poles tend to dominate, especially in the present-day picture. The left side shows the greatest change, with the gabled buildings replaced and the arrival of the modern Co-op store with its green and white paint. On the right the houses remain largely unaltered externally, though the building nearest to camera, Kingston House, indicates how our ancestors enjoyed encouraging creeper to cover walls.

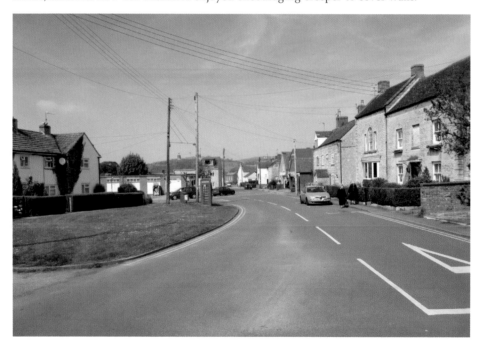

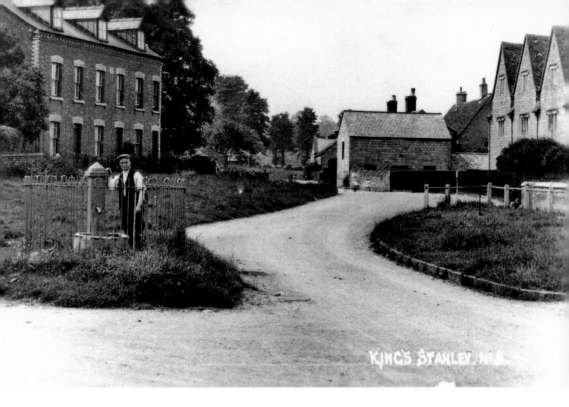

The Pump

Set on its own little island, with railings around it, King's Stanley's parish pump looks ancient. In fact it was only erected in 1908 and removed around 1935. The modern picture was taken from a slightly different angle and closer in, so as to avoid a particularly ugly telegraph pole. The triple-gabled building on the right is the seventeenth-century Borough House. Its stone mullions have dripstones and in the gables are fine oval windows.

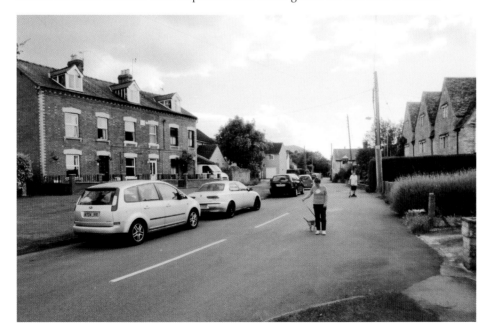

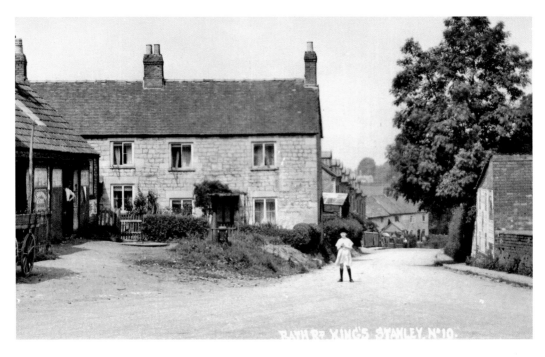

Bath Road

The terrace of red-brick houses in the middle distance and the stone cottages beyond prove that these two photographs are taken from the same place. In the earlier picture, which dates from around 1920, note the building on the right, its wall covered with advertising posters. The stone-built house in the centre has also gone, as has Jehu Shipway's wooden blacksmith's workshop on the left. This firm was also in Ebley and Minchinhampton.

Castle Street

Here is another instance of considerable change; only the buildings in the distance are common to both photographs. The street acquired its name from Old Castle House – not visible here – which was built or remodelled by clothier William Selwyn in 1563 and was later an inn. The terrace with the large central gable, in front of which the people are standing, is Fletcher's Row, demolished around 1960. Judging from the hats the girls are wearing, the picture must date from around 1930.

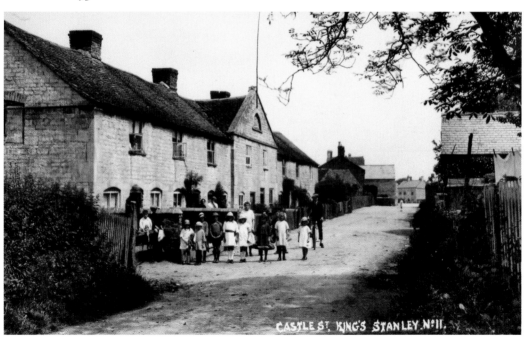

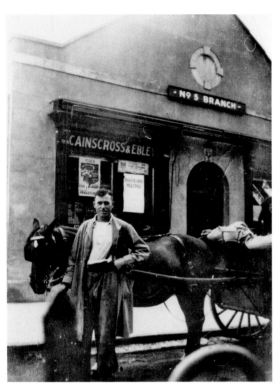

King's Stanley Co-op

A proposal to open a branch of the Cainscross & Ebley Co-operative Society was put before a Quarterly Meeting in May 1901. With assent granted, one was opened in November of that year in premises first occupied in 1870 as the People's Hall and taken over by the Salvation Army in 1881. The purchase price was £150. The sepia picture shows Jim Fletcher of Court Farm, King's Stanley, outside the building in New Street. As the modern photograph shows, it is now flats, with all traces of its central door and two shop windows gone.

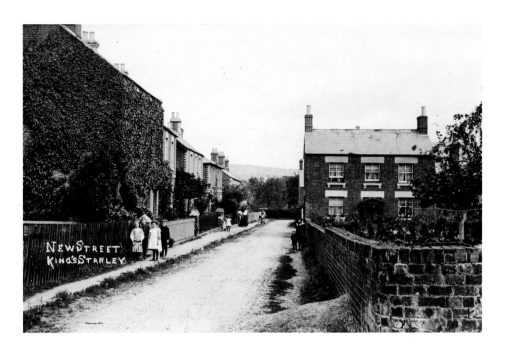

New Street

New Street is a relatively recent addition to the road network of King's Stanley. It was created in 1870, so was only around thirty years old when this postcard was sent. All the children seem aware of the photographer's presence. The street is clearly unmetalled, with weeds and grass invading its edges. The appearance of the house on the right has been altered by the addition of cement rendering and shutters, while the nearest building on the left is so thickly covered with creeper that it is impossible to see its surface.

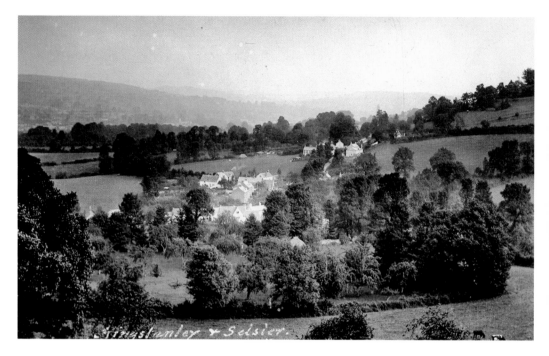

Singstanley & Selsley.

Looking from Penn Lane over Middleyard

It was not possible to take a picture from exactly where the unidentified Edwardian photographer took his, but a resident of Penn Lane kindly gave permission for the author to take the modern comparison shot from his garden – complete with canine foreground. Here we look over the rooftops of Middleyard to Selsley West beyond. The absence of mature elms is noticeable in the present-day image.

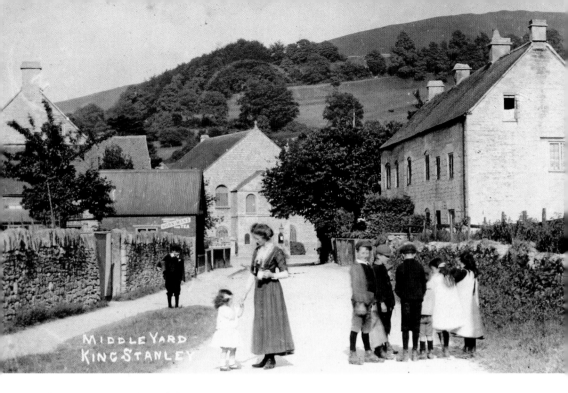

The Baptist Chapel, Middleyard

The chapel is an early one, reputedly founded in 1640, as a plaque on it states. Certainly by 1715 a congregation of 150 was recorded, together with a resident minister. The present building was put up in 1824. With a dwindling congregation, in 2012 a television documentary portrayed a kind of 'reverse missionary' situation, with a visiting Jamaican pastor trying to reinvigorate the chapel. Once again local residents provide a colourful foreground to match the charming scene of mother and children in the sepia postcard, which was sent in 1914.

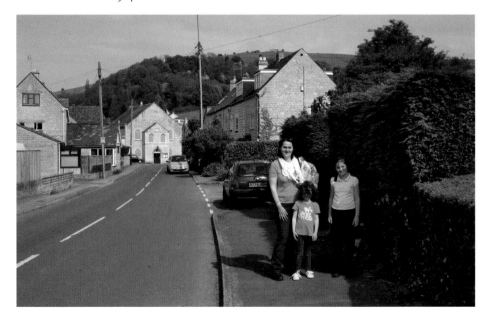

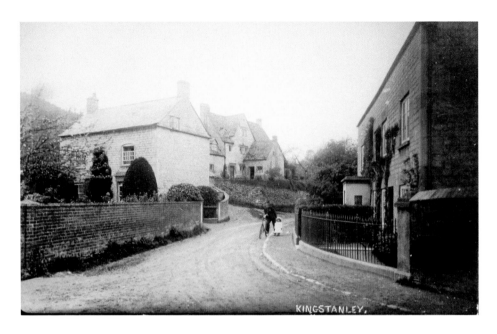

Cyclists at Middleyard

The message on the back of this postcard refers to the man with his bicycle as 'Cousin Basil the postman'. In fact the man in question was Basil Smith, whose son Cyril, by coincidence, was later to marry the author's aunt, Nellie Beard. The children in the present-day picture were spotted one morning out playing with a bicycle and permission was given for them to pose in front of Half Moon Cottage, much as Basil did almost exactly a century before. The dwellings in the background are called The Tump.

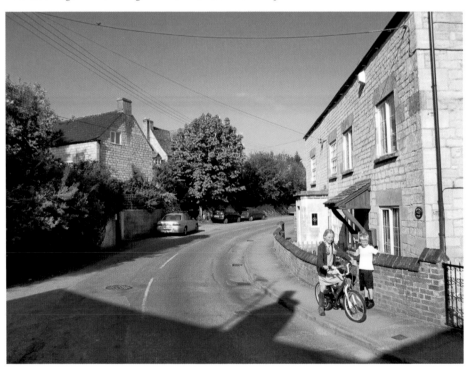

Leonard Stanley

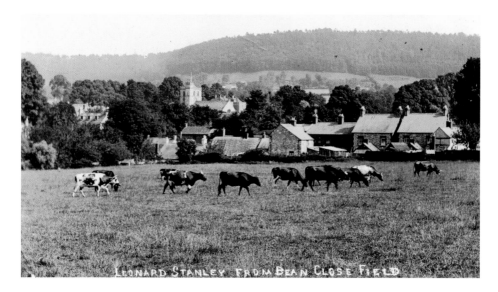

A Distant View of the Village

This scene across the meadow, with Seven Waters in the foreground and the church glimpsed beyond it, provides a most attractive distant view of Leonard Stanley. In the Middle Ages the parish was sometimes known as Monk's Stanley, on account of its priory. The village suffered a severe fire in 1686, in which several houses along the street were destroyed. In 1911 Leonard Stanley had a population of 651. By 1961 this had increased to 1131 owing to new housing.

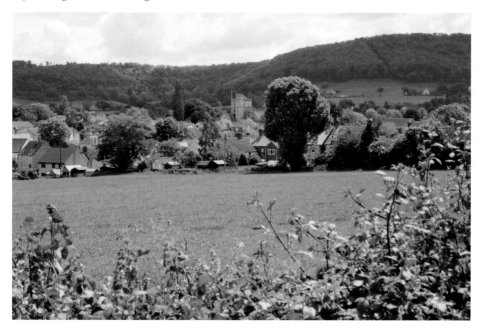

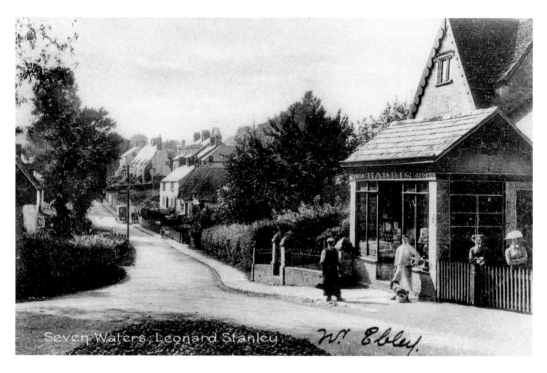

Seven Waters

Seven Waters seems to have acquired its name from a series of ponds formed from the Bitton Brook and one of its tributaries. By the 1960s only two ponds survived. The house on the left at the bottom of the slope was a tannery and has recently been restored. Harris' grocery shop, on the right, survives as a private dwelling.

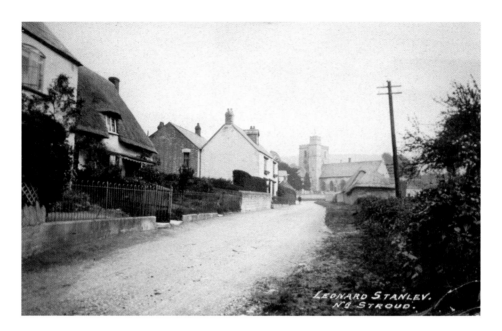

Church Road

It is interesting to see thatch in an area where stone tiles are the traditional roofing material. Properties on the left of the road remain basically the same – even the railings seem to have survived. Everything has altered to the right of the road, which a century ago was surfaced with rolled road-stone. The postcard from which this sepia image comes is curious. The picture was taken around 1910 by Stroud photographer Mark Merrett, but the card was actually posted in 1959; had someone been hoarding it for half a century?

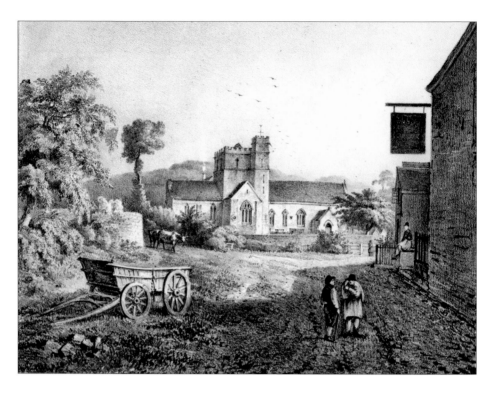

St Swithun's Exterior

The engraving – like the one of King's Stanley Church – dates from the 1830s and was the work of local artist, Alfred Newland Smith. The 'newer' image dates from around 1910 and is brought to life by the group of bonneted girls standing among the tombs. A comparison between the photograph and the engraving shows no significant alterations to the church itself over the intervening years. Formerly the Priory Church of St Leonard, founded in 1131, the building has been dedicated to St Swithun since around the time of the Dissolution.

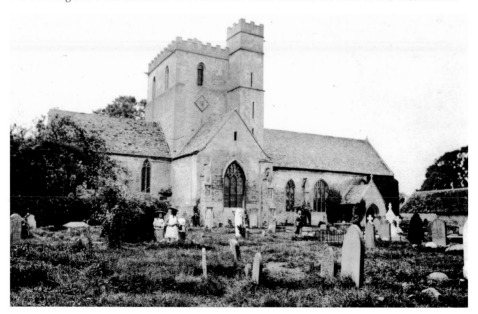

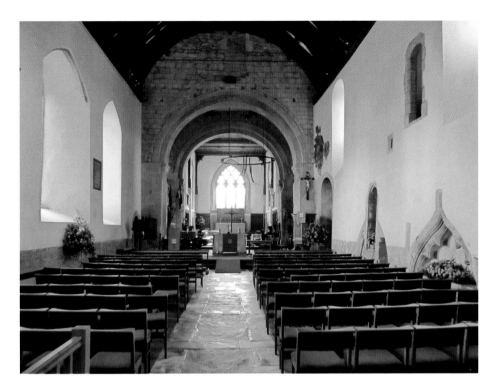

St Swithun's Interior

Changes in lighting are invariably apparent when comparing church interior pictures a century apart in date. But it is the seating that really makes these pictures so different. The box pews were probably installed in the eighteenth century and, though useful for eliminating draughts, must have made worshippers seem very isolated. The present-day photograph shows how restoration has revealed a medieval tomb and the stairway recesses leading to a vanished rood screen.

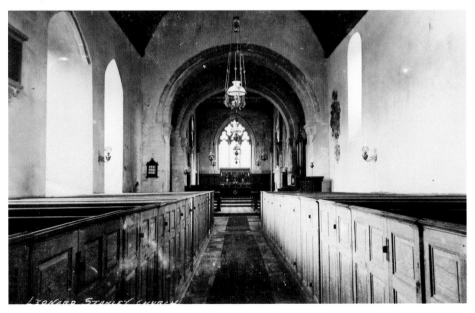

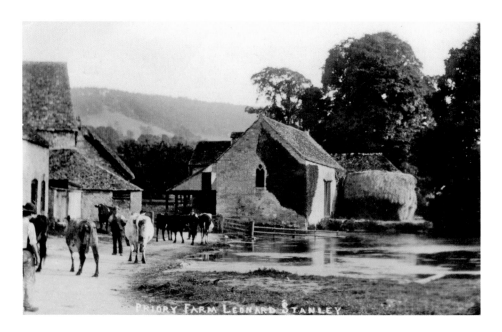

The Priory Buildings

From farmyard level in the period photograph and from the church tower in the modern image, buildings belonging to the former Priory of St Leonard can be seen, their windows suggesting ecclesiastical origins. The early view is from a postcard sent in 1912 by an artist residing at Westbury-on-Trym, near Bristol. This person had obviously been sketching at Leonard Stanley. The card includes the rather sad comment, 'Have just unpacked my painting things and laid them out regretfully in an empty room.' Holidays at an end, perhaps?

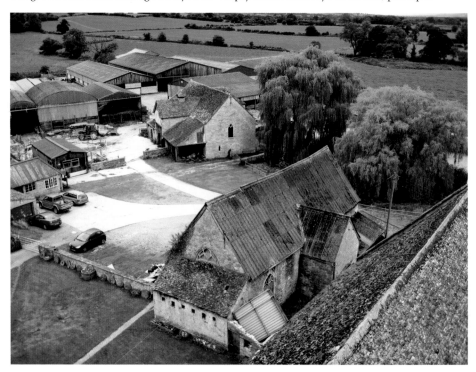

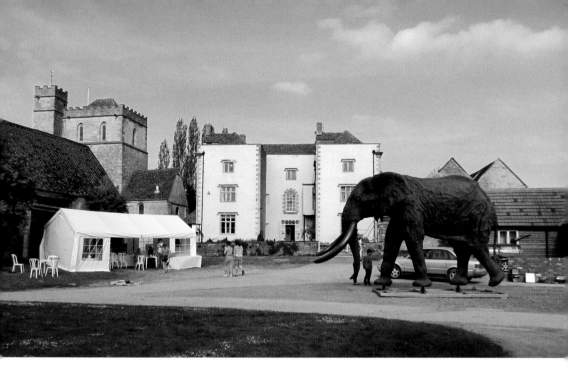

On Safari at Leonard Stanley

The three-storey mansion to the right of the church, The Priory, was bought by Robert Sandford in 1738 and rebuilt *circa* 1750. From the mid-nineteenth century it has been essentially a farmhouse. The view of it across the pond was taken around 1925 by Monmouth photographer W. A. Call and is one of a series. Tree growth has made it necessary for the present-day picture to be taken closer to the house. The last thing the author expected to include in it was a full-size sculpture of an African elephant, destined shortly to leave its temporary home and travel to Texas! Created by the artist Michael Ghaui, it was cast in the Pangolin Studios at Chalford.

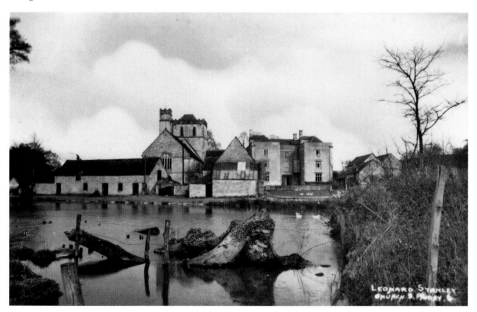

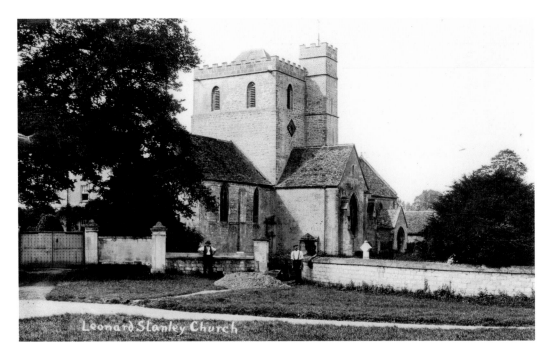

The Church from the East

With its squat tower and attached turret, St Swithun's Church is an easily recognisable landmark in the Stonehouse Valley. The 1920s picture is the work of William Adams, mentioned earlier. William worked as a supervisor for the GPO and his job involved visiting local sub-post offices in the Stroud area. These furnished him with convenient outlets for selling his postcards. The author has discovered several hundred examples of his work, always unsigned but recognisable from his distinctive handwriting.

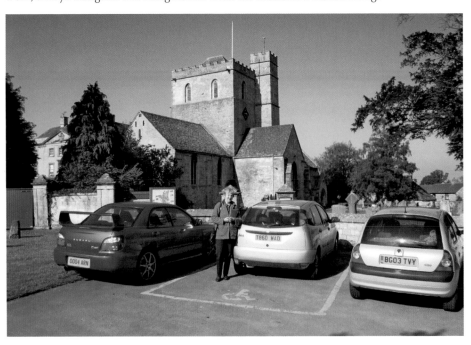

Church Road, Looking West

It is fascinating to look in detail at how buildings and landscapes change. About eighty years separate these two pictures, during which time television aerials and overhead wires have proliferated. The first house on the right, Church View 2, has been re-pointed, with most plants removed from its wall. Next door, Church View 1, with its magnificent display of wisteria, has been more radically altered, with new raised dormers, a porch added and its frontage painted over, concealing the arches above its windows. The house immediately to the left was the Cross Keys Inn.

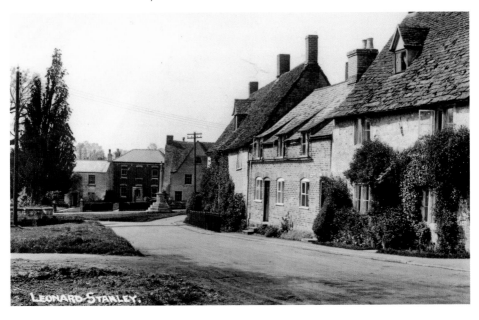

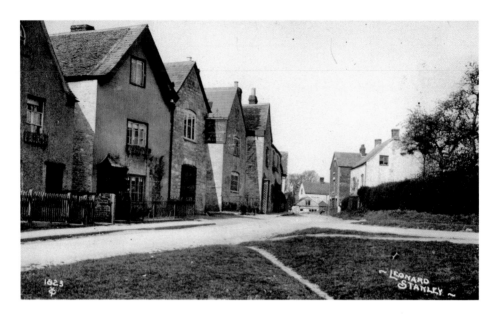

The Green

The wall of a building shown on the preceding page was painted over. Here the opposite has happened and the property on the left, Winchcombe House, has been stripped back to its Cotswold stone and half-timbered gable. In the middle distance is the White Hart. The inset shows a plaque, installed recently to commemorate the time during July 1939 when the artist Sir Stanley Spencer stayed in the pub. When it was fixed to the wall, local people posed in the same positions as those in the painting *Village Gossip*, which he completed while living at the inn.

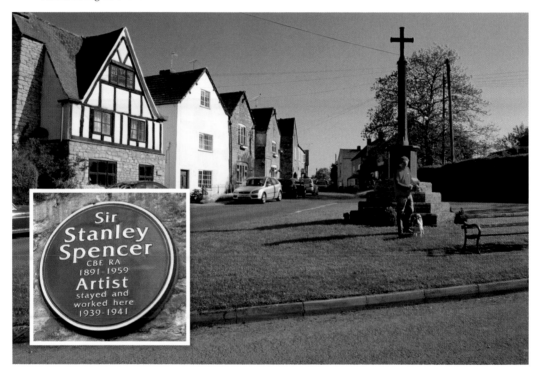

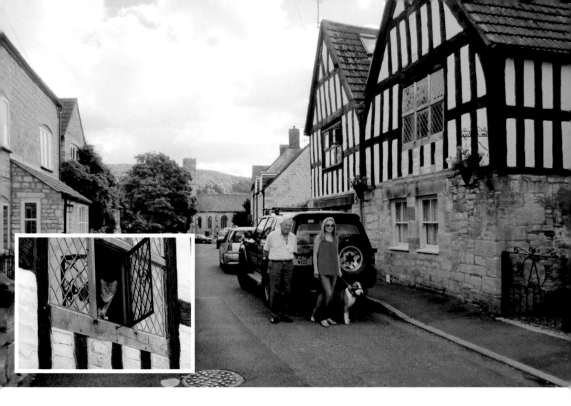

The Street

This lovely old photograph was taken around 1906 by Stonehouse photographer Frederick Restall. Local children have been persuaded to line up for him, together with a couple of men with garden tools. The child on the left has a metal hoop, a common toy in Edwardian days. The building on the right, which now has a plaque with 'The Weaver's House' fixed to it, clearly survived the fire of 1686 and is arguably one of the village's finest period houses. The inset shows an inquisitive feline occupant that the author found irresistible.

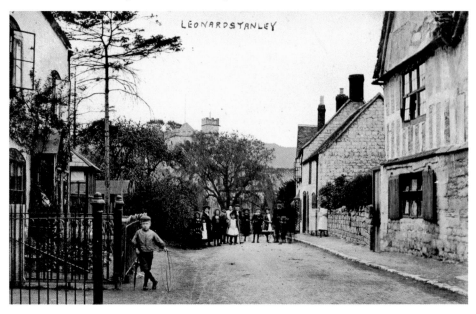

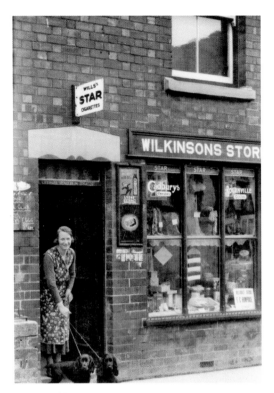

Wilkinson's Shop

Mr and Mrs Wilkinson ran their shop in The Street between 1933 and 1947. The photograph shows Mrs Alice Mabel Wilkinson at the door with the family's pet spaniels. Today the building shows no sign that it ever housed a business – in fact it is really only the chamfered door lintels that prove it is the same structure. Friendly neighbours agreed to be included in the present-day picture.

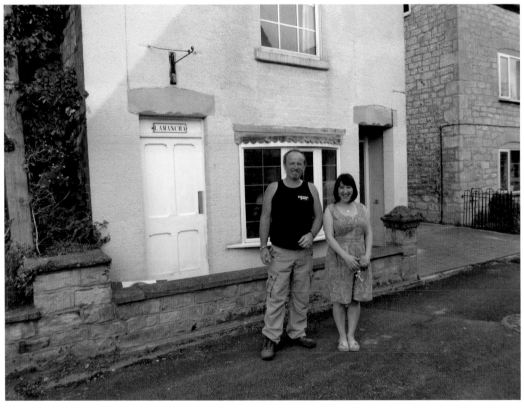

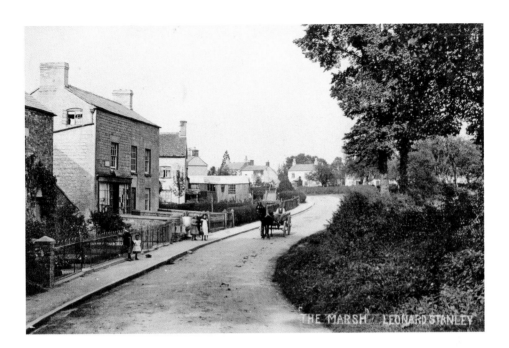

The Marsh

This is another fine picture by Frederick Restall, dating from around 1907. The shop on the left served both as Leonard Stanley's post office and a stationer's business, run at this time by Mrs Angelina Farmiloe. The cart approaching down the road gives atmosphere to the photograph, as do the children on the pavement with their white pinafores. The postcard was sent to an address in Brighton and included the following message: 'This is such a pretty village and lovely country all round. I wish it would set fine!'

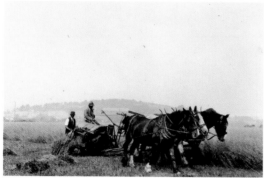

Mowing Hay

The black-and-white photographs are of hay being cut in the field opposite Grey Cottage, alongside the road to Stanley Downton, at the junction of Bath Road with Marsh Road. Taken in 1940, they show farmer Harry Godsell on the left of the lower scene. Images of this type really do record the end of an era; the days of the working horse were rapidly drawing to a close.

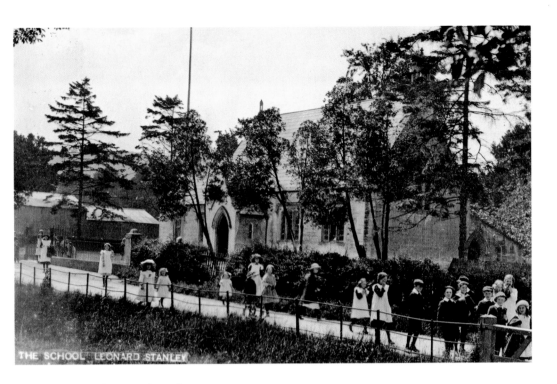

THE SCHOOL LEONARD STANLEY

Children of Leonard Stanley

The earlier of this pair of photographs shows children in front of Leonard Stanley School around the time of the First World War. Education is first recorded in the village in 1712, when a clothier's will gave 40 shillings for teaching poor children reading, writing and the principles of religion. By 1833 there were two day schools teaching a total of forty-two children, a charity institution and two Sunday schools. The old building, now the village hall, was erected in 1850. The present-day photograph, taken by local camera enthusiast Revd Noel Baker, is of a scene from the 2011 Village Fête.

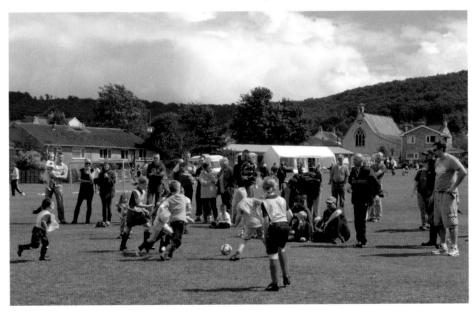

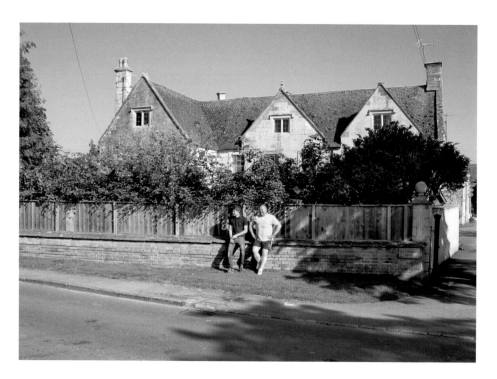

The Grange

Formerly known as Townsend House, this fine edifice was also called The Grange and has now been further renamed Clutterbuck House, after the family who occupied it in 1580. The building has an interesting subsequent history, being owned by several different families during the eighteenth and early nineteenth centuries. Sash windows were installed in some areas of the house during the Georgian period, while elsewhere original stone mullions with dripstones survive. Once again we see how popular creeper was. The photograph dates from around 1930 and is once more the work of William Adams.

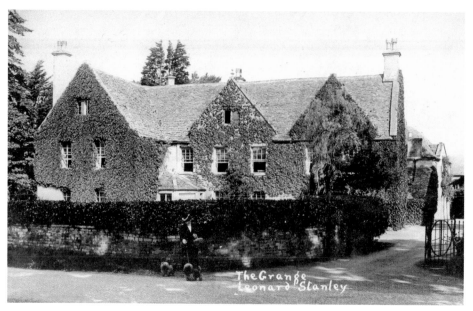

Stonehouse

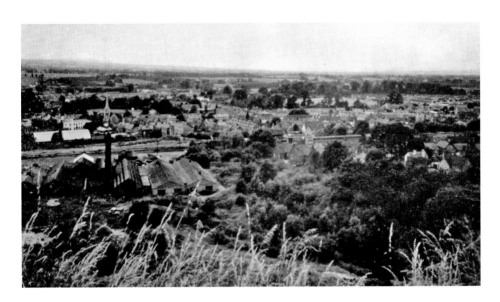

A View over the Town

Moving into the parish of Stonehouse, the obvious place from which to take a general photograph is from the slope of Doverow Hill. The earlier picture, of uncertain date, shows in the foreground the extensive premises of the Stonehouse Brick & Tile Co. Ltd, founded in 1891. This firm made not only house bricks, but also terracotta and possibly pottery, though no examples have come to light. Wycliffe College Chapel is clearly visible beyond the factory, with the main part of the town off to the right. The modern picture shows how the former brickworks site and its surroundings have been developed for housing.

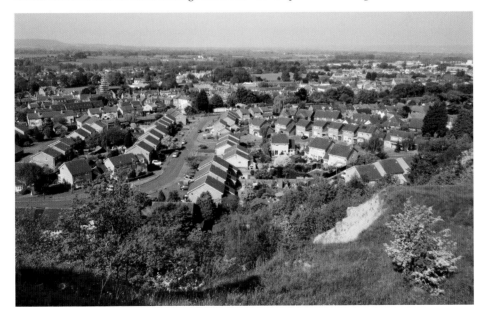

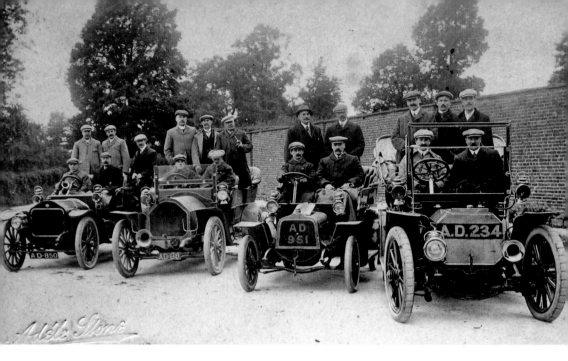

Motoring at Ryeford

The Edwardian decade saw a huge interest in motoring among well-to-do people. Here, captured through the lens of Stroud photographer Adèle Stone, we see a quartet of splendid 'AD' Gloucestershire-registered motor cars lined up around 1908–10 by what is now the Ryeford roundabout – the wall in the background confirms the location. Adèle was born Ada Ellen Barnes, daughter of a Kent photographer. George Stone joined the firm and married the boss's daughter. They came to Stroud just after 1900. The vehicle on the left is a Wolseley (*c.* 1908) driven by Tommy Reed, Stroud's first taxi driver. Next is a Darracq (*c.* 1907) then a Talbot (*c.* 1904) and finally a Peugeot (*c.* 1908), owned and driven by Charles Apperly (see page 9 – same number, different vehicle).

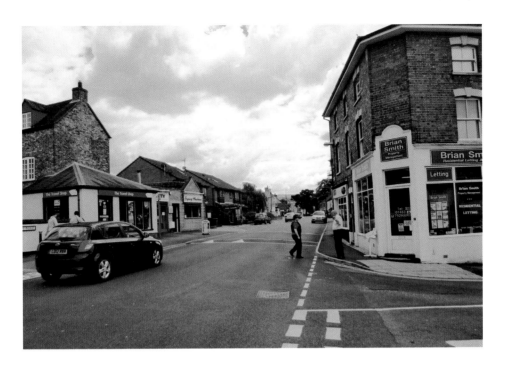

Bath Road

The building on the right is obviously the same in both photographs, but the whole of the left side of the picture looks so different. Mullins' clothing business has its doorway festooned with garments and the sign above proudly announces 'hard-wearing school boots for boys and girls'. The shop is currently a letting agent's. On the left of what the photographer calls Stroud Road – it should be Bath Road – is Henry Perkins' cycle premises, reminding the viewer that for most people in 1908, when the photograph was taken, a bicycle was the only means of transport commonly available.

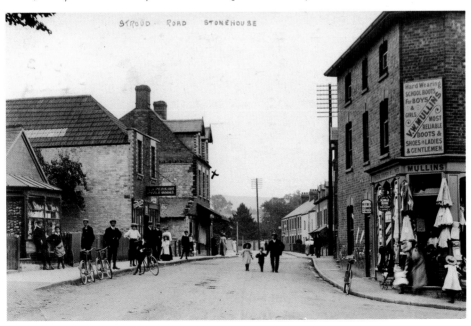

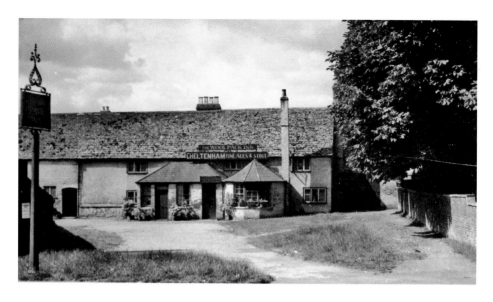

The Woolpack Inn

This picture appears on a postcard sent in 1940, though the image is probably a good deal older. The writer of the card complains that 'it is small and inconvenient inside, so that if the war had not come they would have rebuilt it'. What he mentions is actually what most people today find charming about the building's interior. Unusually, the inn is supplied from Cheltenham rather than Stroud. Earlier, from 1901 to 1908, it was owned by Nailsworth Brewery. The inset picture is taken from a county directory; the 'Special Family Ale at 1s per gallon' sounds particularly attractive.

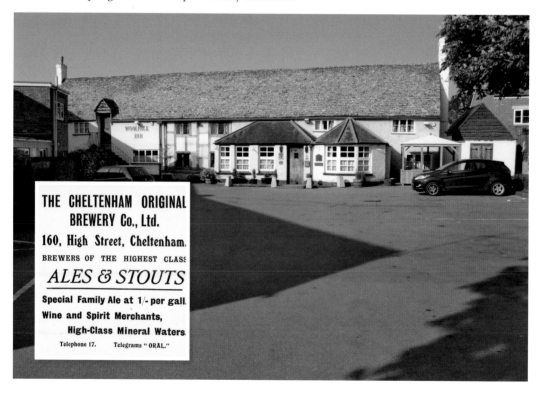

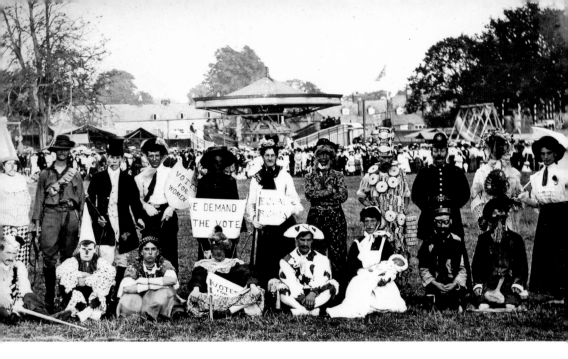

Fun and Games

The Edwardian picture shows a summer fête or carnival, with fancy-dress parade contestants lined up for photographer Frederick Restall, whose studio was in the High Street. Among those pictured are a matador, clowns, a gypsy, a huntsman, suffragettes, a man dressed as a nanny, a policeman and – surely the most original idea – standing fourth from the right, a competitor wearing a costume made almost entirely of Moreland's matchboxes! The modern counterpart to this photograph was taken at the 2011 Summer Jolly in Stonehouse and shows former MP David Drew observing children in huge padded costumes involved in mock combat.

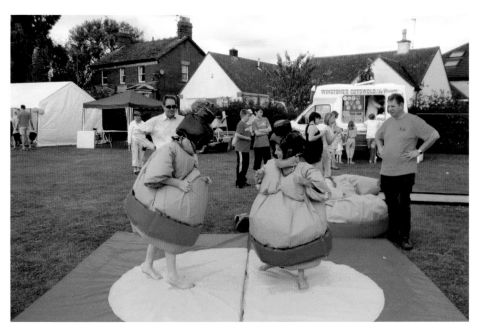

The Eastern Part of the High Street

It comes as a surprise to many today that telegraph poles were so large and intrusive in the 1920s, when this photograph was probably taken. Eastman's butchery business is on the right, with a pony and trap pulled up outside. The further sun-blind on the left extends over the window of Timbrell's stationer's, formerly Mark Whiley's. Both owners produced a series of picture postcards of the town. Sent to an address in Surrey, the card consists of the signatures of members of the Perkins, Horsham and Holder families.

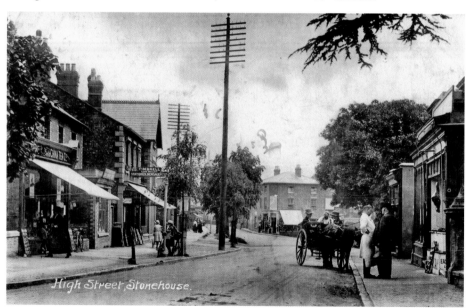

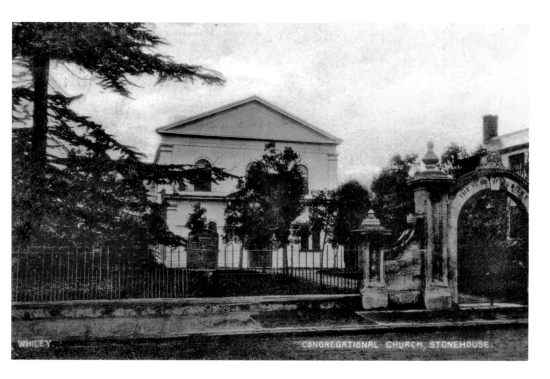

The Congregational Church

Many people might be surprised to learn that in the High Street, on the site of the NatWest Bank that has recently closed, there once stood a chapel. However, proof – if needed – lies in the tombstones that survive at the rear of the building. The edifice as seen in the postcard view was built in 1827. By 1851 it had a congregation of some 300 persons. Services ceased in 1965, the chapel burnt down in 1967 and was demolished shortly afterwards.

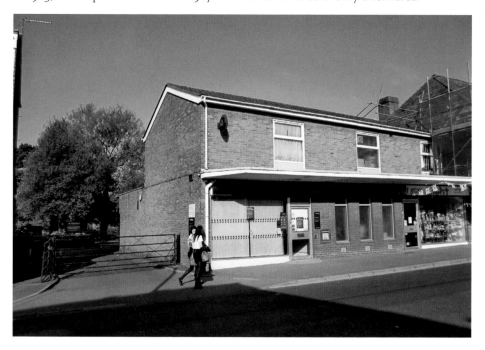

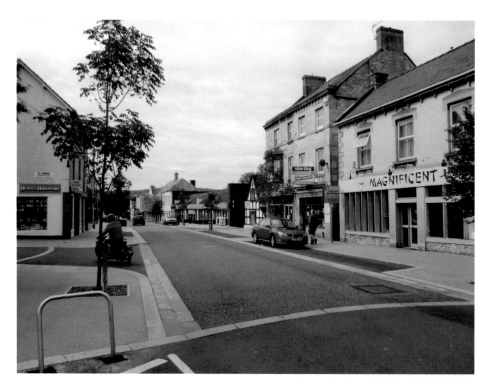

Shops Further along the High Street

This postcard is an attempt – really none too successful – at colour photography. The shop on the extreme right housed Fawkes' Stores. It is now the Magnificent Wok. The creeper-covered building next to it is now home to a butcher's and (until recently) a baker's that claimed to have been founded in the eighteenth century. The small, gabled structure is now an Indian takeaway. Beyond that is Gardiner's Garage, with its curved roofline, taking up most of the site now occupied by Stonehouse's large Co-operative store.

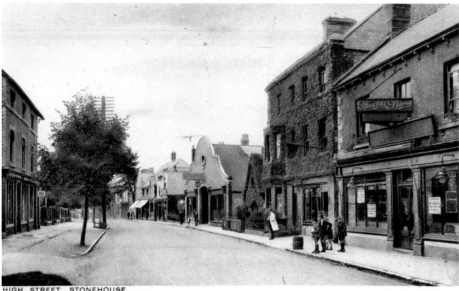

HIGH STREET. STONEHOUSE.

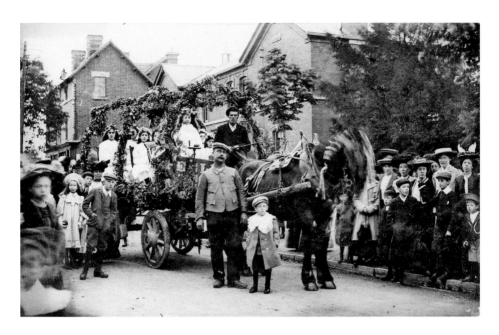

The Old Police Station

The horse-drawn cart carries what is believed to be the 1906 May Queen and her young attendants. The decorations on the vehicle illustrate the effort typically put into making events special during Edwardian times. The group is passing the old police station, currently divided into commercial units. It is a handsome building with impressive chimney stacks. Constructed in 1890 in bricks from the Atlas Company run by the Jefferies family, and with windows of Cotswold stone, it was manned in 1910 by a sergeant, Frederick Townsend, assisted by one constable.

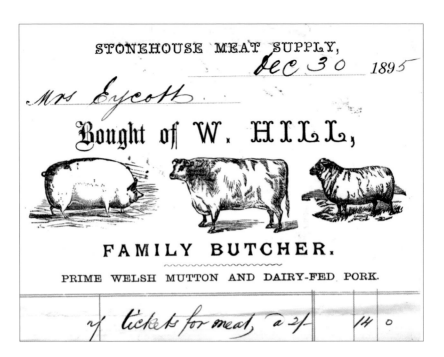

STONEHOUSE MEAT SUPPLY,

Dec 30 189*5*

Mrs Eycott

Bought of W. HILL,

FAMILY BUTCHER.

PRIME WELSH MUTTON AND DAIRY-FED PORK.

| *of tickets for meat, a 2/-* | *14* | *0* |

Butchers

In 1895 W. Hill ran the Stonehouse Meat Supply. The location of his premises is uncertain. His customer, a Mrs Eycott, apparently bought her meat using a ticket system. The artwork on the firm's invoice is attractive and typical of late Victorian letterheads. By 1910 the town supported four butchers and a fishmonger. In Stonehouse there were also, among many other businesses, a wheelwright, a herbalist, a market gardener, a marine store dealer, a saddler, two sweeps, a watchmaker and a brush maker. The present-day photograph shows butcher Phil Johnston inside Broomhall's premises in the High Street.

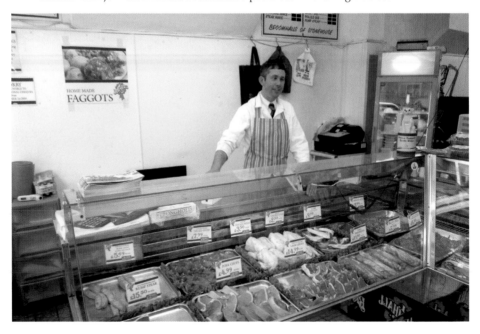

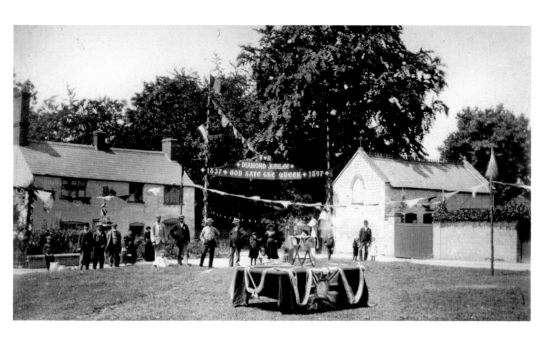

Diamond Jubilees

Queen Victoria's Diamond Jubilee celebrations took place on 22 June 1897. They included a programme of sports. Entrants had to be either parishioners or employed in the community. The list of events incorporated a 'race for men over fifty, for a new hat' and a wheelbarrow race in costume. There were ten different bicycle competitions, among which were egg-and-spoon, carpet-bag and needle-and-thread races, and also a bottle-and-ball competition. Victorians, it seems, *were* amused! Moving forward more than a century, the coloured photograph shows the Stonehouse Mayor, Councillor Chris Brine, lighting the 2012 Diamond Jubilee beacon on Doverow Hill.

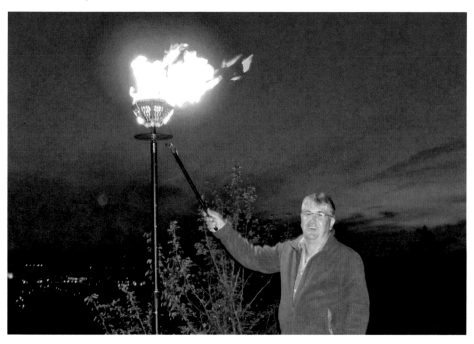

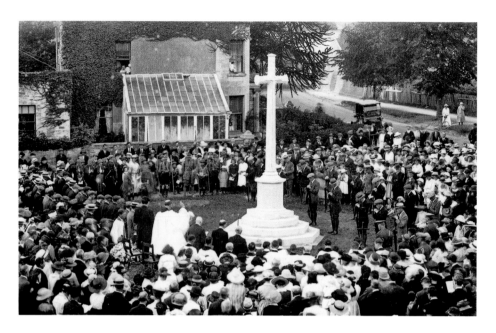

The War Memorial

Photographer Henry Lockyer recorded the unveiling of the war memorial on the Green on 12 August 1919. Revd Waugh, the vicar, performed the ceremony. Pictures exist of similar ceremonies throughout the district. It is hard for us today to understand how significant an occasion this must have been. All present would have known personally so many of those who lost their lives. Over 180 men from the parish are recorded as taking part in the First World War; fifty-two lost their lives. Eight fighting men were awarded distinctions, including Sgt C. H. Gardner, who received the *Medaille Militaire*; he was also mentioned in dispatches, as was Capt. T. M. Sibly from Wycliffe College.

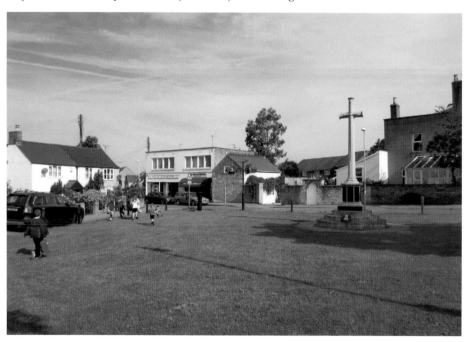

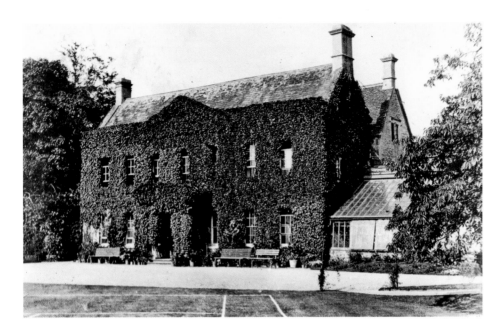

Haywardsend House

Now part of Wycliffe College, this well-proportioned edifice dates from the seventeenth century, when it was owned by the Fowler family. The south front, which was put on in 1789, has a portico with paired columns. The building takes its name from the Hayward family who owned it in the nineteenth century. In the modern picture it is bereft of the covering of creeper thought so attractive a century ago. The large greenhouse has been replaced by the red-brick structure with arched windows, to the right of which is the new dining hall, opened by the Princess Royal. To the left is the school's science block.

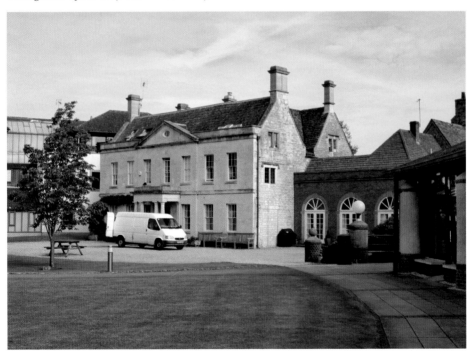

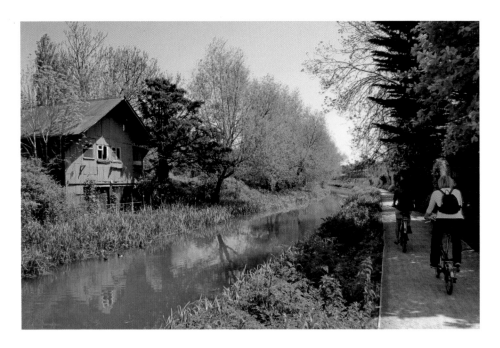

Wycliffe College Boathouse

Close to the college, on the Stroudwater Canal, lies the former boathouse used by Wycliffe rowers. In the black-and-white picture, one of a series by specialist educational photographer P. A. Buchanan of Croydon, boys have been posed together with what must surely have been the school's entire 'fleet' of craft. With dredging complete and a newly surfaced towpath, the dereliction that was evident here for so long has now been much reduced. When taking the modern photograph, the author was most entertained by the antics of a pair of diving ducks just visible near the boathouse.

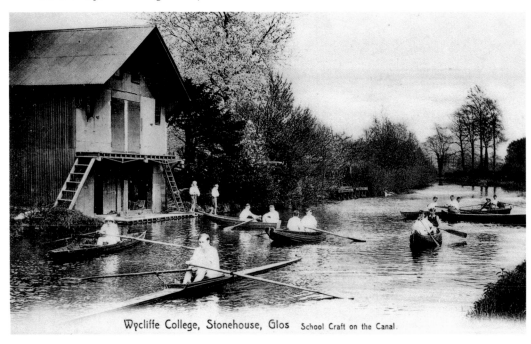

Wycliffe College, Stonehouse, Glos School Craft on the Canal.

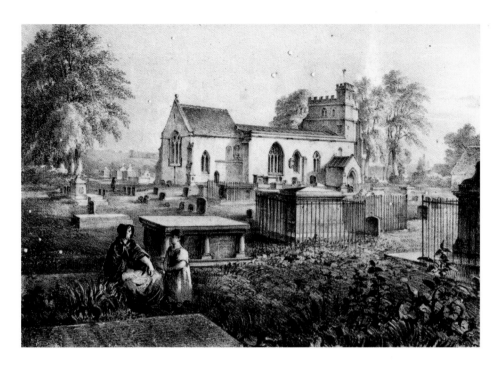

St Cyr's Church

Here we see another print, taken from a volume splendidly entitled *Twenty Lithographic Views of Ecclesiastical Edifices in the Borough of Stroud*, printed and published by J. P. Brinsley in 1838. The book was priced at 15s for subscribers and 21s for non-subscribers. As stated earlier, the engravings were by Alfred Newland Smith, a member of a family of local artists and photographers. The print is important because it predates major structural changes that took place between 1852 and 1855. The mother and child in the engraving are typical of Smith's artistic style. The church's dedication to St Cyr is unusual.

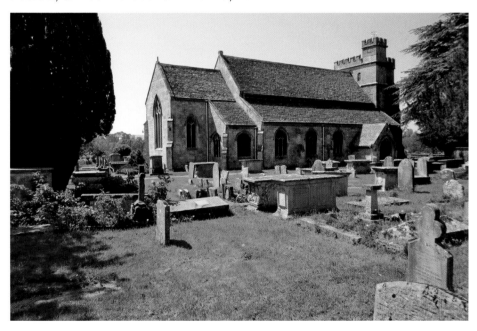

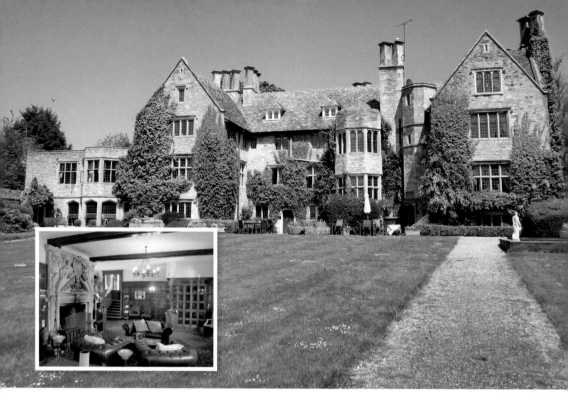

Stonehouse Court

Stonehouse Court was rebuilt by the Fowler family in 1601, although its history extends back much further. After passing through various hands, including the Marlings, in 1906 it was bought by A. S. Winterbotham of Cam, who owned it until his death in 1936. His widow, Caroline, continued at Stonehouse Court until her death in 1975 in her 100th year. It became a hotel in 1983. Around the time of a major fire in 1908 a series of photographs was taken – one is reproduced here. The present-day picture shows the exterior from the south, with an inset view of one of the principal rooms.

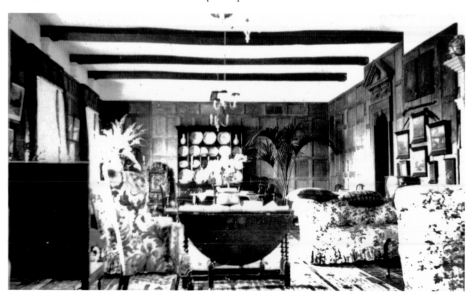

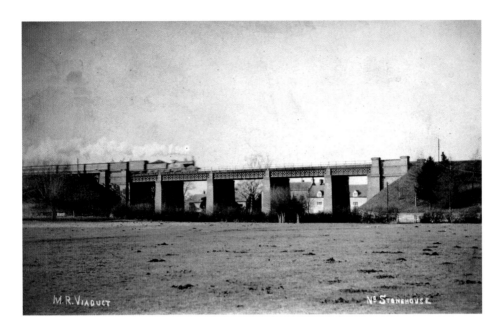

M.R. Viaduct N° Stonehouse.

The Midland Railway Viaduct

Near the Ocean, close to Stonehouse Church, the main Gloucester to Bristol line passes along a viaduct. The railway line was constructed by Brunel as part of the GWR network and then taken over by the Midland Railway a few months later in 1844. The sepia picture dates from around 1910. Today most of the viaduct is obscured by foliage during summer months. The 2012 picture was photographed from higher ground next to the Ocean, where the line is completely hidden by trees. The author persuaded a lady and two small children to add colour to what would otherwise be a rather empty foreground.

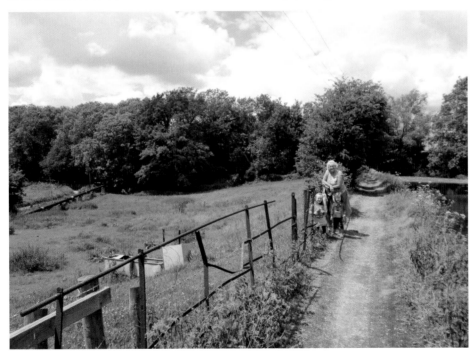

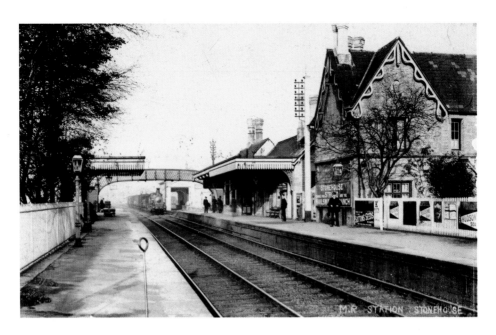

Stonehouse Midland Railway Station

Today it would be difficult to stand where the 1905 picture of Stonehouse Midland railway station was taken, so the colour photograph is from the other side of the track in what is now part of an industrial estate. Everything else has gone. A board says, 'change for Stroud and the Nailsworth branch'. The Midland station has all the furniture those of us of a certain age remember from our childhood – luggage trolleys, gas lamps, seats with curved iron arms and, above all, advertisements – in this case for Sutton's Seeds and Hudson's Soap.

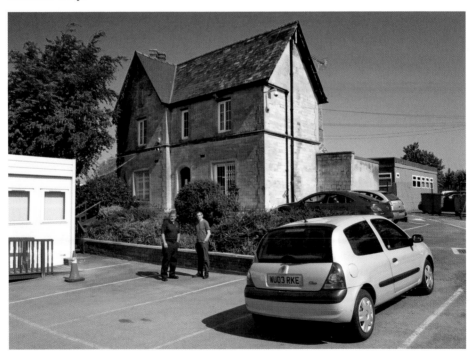

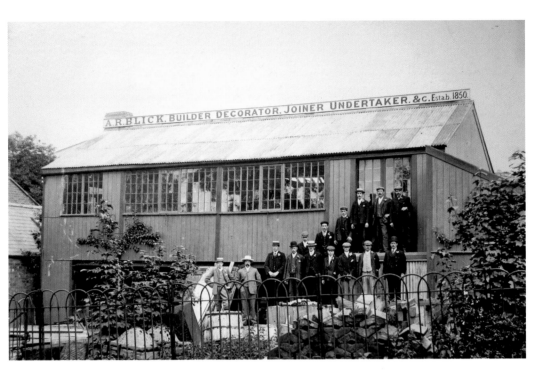

A. R. Blick's Building Business

This firm began as a chandler's in 1850, developing into a building and undertaking concern, and for many years was one of Stonehouse's best-known businesses. Its premises were in Queen's Road. The site is now occupied by the modern houses shown in the present-day photograph. Mr Alan Blick was the last family member to run the firm and it is with the permission of his widow, Mrs V. Blick, that the Edwardian photograph of the workforce setting out for a trip to Weston-Super-Mare is reproduced. Its title, *'Off-Duty' Rendez-vous, Weston*, suggests a firm that cared for those in its employment. Set back from Queen's Road, the large building in front of which they pose is no longer standing.

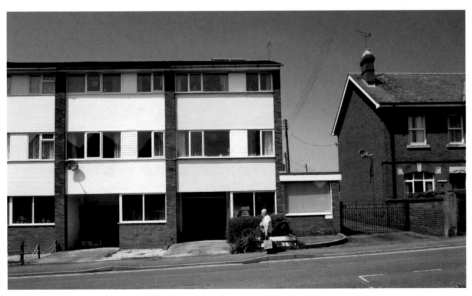

93

Stonehouse Station

The GWR station opened in 1845. It was on the line created by Isambard Kingdom Brunel to link Swindon with Cheltenham. Much of the survey work for this stretch was undertaken for Brunel by a young engineer called Charles Richardson, whose journal came to light a few years ago. On the night of 12 October 1836, Richardson stayed at the Crown & Anchor while working in Stonehouse. The sepia photograph shows a group, probably dressed up for an outing, on the footbridge put up by the GWR in 1890 (see the company's logo in the inset). The clothes suggest a date around 1920. The modern-day view is taken from the footbridge.

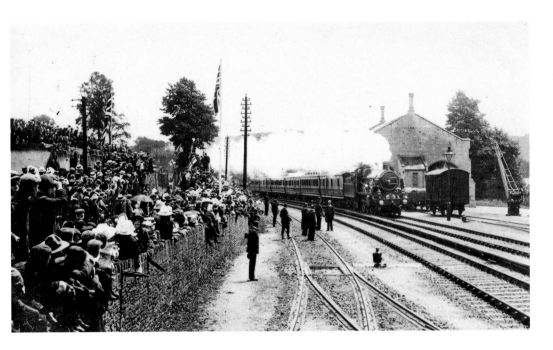

A Royal Train Passes Through

On 23 June 1909, King Edward VII passed through Stonehouse bound for the Royal Agricultural Show at Gloucester, where householders hired out upstairs windows for spectators to see him. As the photograph shows, a substantial crowd of people assembled near the brickworks to catch a glimpse of the royal party, and Stroud photographer George Stone was there to capture the scene. Stands were provided for children to get a good view of His Majesty but, in fact, the train passed at 60 mph and the disappointed children saw nothing! In the distance beyond the locomotive is the old GWR engine shed. Today the Brick Company's premises have been replaced by Rosedale Estate.

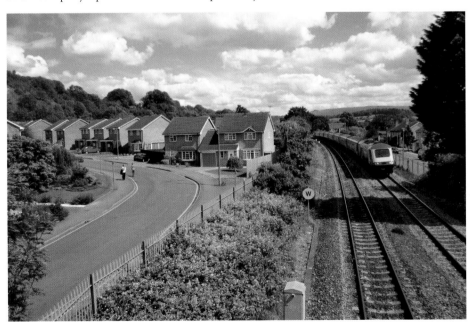

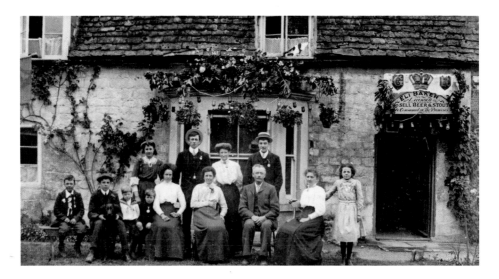

The Spa Inn
The Spa Inn in Oldends Lane, with its modern extension to the right, is still very much a going concern. Taken in the summer of 1911, the sepia photograph shows the pub decorated for the Coronation of King George V and Queen Mary, with the landlord, Eli Baker, and his family in front.

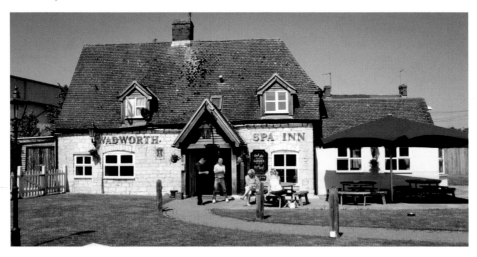

Acknowledgements

The late L. Baker, Revd N. Baker, Ms A. Blick, Mrs V. Blick, M. Fletcher, P. Harris, A. Holley, the late F. Rowbotham, Mr & Mrs C. Rudall, Stonehouse Court Hotel, P. Taubenheim, P. Wilkinson, Wycliffe College. I would like to thank Mrs S. Dicker, J. Dickson, P. Griffin, J. Hale, Mrs D. Tucker, Mrs V. Walker and R. Woodward for proofreading. I am also grateful to my wife, Sylvia, for her invaluable assistance and advice.